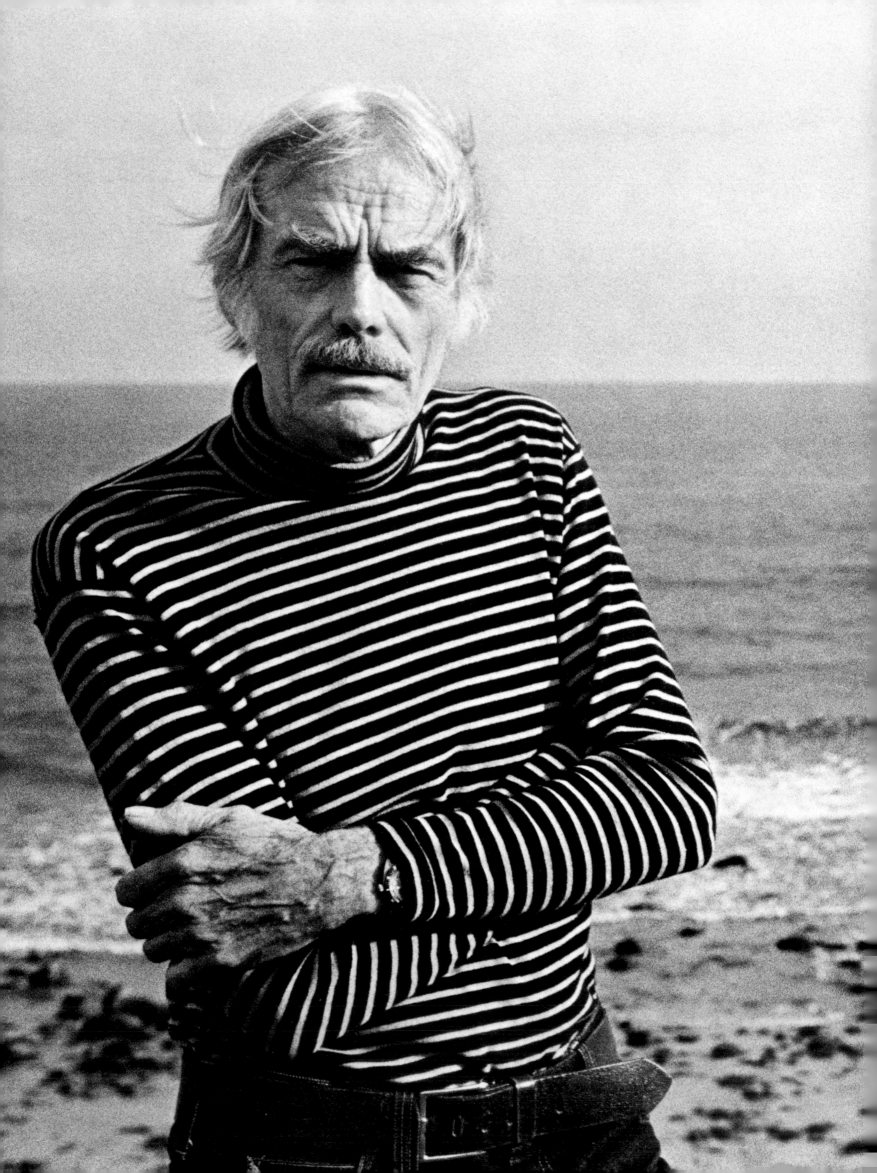

Overleaf: Balcomb Greene, photograph by Hans Namuth

THE ART OF Balcomb Greene

TEXT BY ROBERT BEVERLY HALE and NIKÉ HALE

Horizon Press New York

Authors' Acknowledgements

We should like to thank the Art Students League,
especially Lisa Specht, President, the members of
the Board of Control, and Stewart Klonis, Executive
Director, for making this book possible. Others
who have greatly assisted are Elliot H. Brown, Lanthear
Costello, Peter L. Felcher, Michael Hecht, Arthur Kalish,
Korby, Gertrude Pascal, Robert S. Perlstein, John Reed,
Ray A. Roberts, Martin J. Sand, Joseph Solomon,
Anselm P. Vischio and David T. Washburn.
We are most indebted to Lloyd K. Garrison for
his kind encouragement and gracious preface.

Contents

Preface by Lloyd K. Garrison 9

Balcomb Greene by Robert Beverly Hale & Niké Hale 10

THE PLATES

(Dimensions: height precedes width)

Art Front Magazine cover (1936) 12¼ × 9, Artist's collection 25

Oil on Paper (1936) 12 × 9, Artist's collection 26

Abstraction II (1936) 24 × 36, Artist's collection 27

Composition (1936) 30 × 46, Artist's collection 28

American Abstract Artists cover (1938) 9¼ × 6¼, Artist's collection 33

Blue Space (1941) 20 × 30, Artist's collection 34

Monument in Yellow (1941) 32 × 48, Artist's collection 29

A Scene from Molière (1945) 30 × 40, Artist's collection 35

The Cry (1947) 30 × 40, Artist's collection 30

The Execution (1948) 30 × 40, The Museum of Modern Art, Katherine Cornell Fund 31

Waiting Figure (1949) 48 × 36, Guild Hall Museum, Southampton, New York 36

The Tragic Actor (1949) 48 × 36, Artist's collection 32

Apparition (1951) 40 × 30, Private collection 41

Abstraction—Figures (1951) 48 × 32, Gift of Mrs. Alan Stroock, Vassar Art Gallery, Poughkeepsie, New York 42

Olympia (1951) 30 × 40, Artist's collection 43

Nude in Yellow Ochre (1952) 36 × 48, Artist's collection 44

The Flag (1952) 36 × 50, The Metropolitan Museum of Art, Arthur H. Horn Fund, 1954 45

Figure Lost in the Light (1953) 36 × 48, Alice and Jack Kaplan 37

Composition—The Storm (1954) 36¼ × 48, Whitney Museum of American Art 46

Woman Dressing (1955) 50 × 40, Private collection 47

Anguish (1956) 48 × 60, Artist's collection 48

Seated Figure (1956) 72 × 56, Artist's collection 49

Seated Figures (1957) 50 × 56, Alexis Smith and Craig Stevens 50

Figure Becoming Abstract (1958) 36 × 50, Private collection 51

Gertrude II (1958) 64 × 50, Mr. & Mrs. Joseph Weinstein 52

Gertrude III (1958) 62 × 50, Private collection 38

Double Portrait (1958) 50 × 62, Dr. Bertram Slaff & Coleman Dowell 53

Abstraction—Storm (1958) 50 × 62, Artist's collection 54

Gertrude IV (1958) 49 × 40, Private collection 55

Driftwood Cove (1958) 30 × 40, Private collection 56

Youth (1959) 62 × 48, Artist's collection 65

Darkness and Light (1960) 45 × 57½, Private collection 66

Paris (1960) 54 × 42, Private collection 67

Man (1961) 50 × 45, Dr. & Mrs. Joel Katz 68

The Boulevard—Paris (1961) 63 × 68, Private collection 69

The Cathedral—Paris (1961) 56 × 44½, Mr. & Mrs. C. S. Winston, Jr. 70

Bicycle Riders of Amsterdam (1961) 68 × 60, Private collection 71

Parade (1961) 56 × 44, Private collection 72

Boulevard Haussmann (1962) 50 × 40, Mr. & Mrs. A. Itkin 73

Northern Harbor (1963) 56 × 44, Private collection 74

The Harbor (1963) 44 × 54, Private collection 75

The Deserted Coast (1963) 60 × 56, Mr. & Mrs. Joseph Weinstein 39

The Avenue—The People (1963) 46 × 56, Private collection 76

Place du Châtelet (1964) 42 × 54, Dr. Thomas A. Mathews 77

Place Pigalle (1964) 58 × 64, Private collection 78

Tourists (1964) 40 × 54, Private collection 79

The Enormous Wave (1964) 44 × 54, Artist's
 collection *80*
Bois de Vincennes (1964) 44 × 54, Milton S.
 Leidner *81*
Boulevard St. Michel (1965) 40 × 52, Private
 collection *82*
The Cliffs Near Montauk Point (1965) 66 × 60,
 Private collection *40*
The Fog (1965) 42 × 52, Private collection *57*
The Lady (1965) 56 × 46, Artist's collection *83*
Maine (1965) 40 × 50, Private collection *84*
Summer at St. Tropez (1965) 44 × 48, Private
 collection *85*
Northern City (1966) 46 × 56, Artist's
 collection *86*
Hill Town (1966) 60 × 55, Private collection *87*
Two Figures (1966) 32 × 40, Artist's
 collection *88*
Le Pont Neuf (1967) 48 × 56, Artist's
 collection *58*
Wyverin II (1968) 46 × 50, Private collection *89*
The North Sea (1968) 40 × 50, Private
 collection *90*
Bathers (1968) 56 × 48, Mr. and Mrs. George
 Gianis *91*
Armada (1969) 50 × 62, Private collection *92*
Island Harbor (1969) 50 × 62, Artist's
 collection *93*
Beside the Sea (1969) 42 × 52, Artist's
 collection *94*
The Squall (1969) 46 × 50, Private collection *95*
Looking-Glass Woman (1969) 50 × 62, Artist's
 collection *96*
Sleeping on the Beach—II (1969) 40 × 50, George
 Rusu *97*
Afternoon by the Sea (1969) 62 × 50, Private
 collection *59*
Wind and Sails (1969) 36 × 46, Artist's
 collection *98*
View of Tangier (1969) 44 × 56, Hugh Van
 Cleve *99*
Bay of Tangier (1969) 36 × 46, Artist's
 collection *100*
Man and Woman (1970) 56 × 50, Mr. and Mrs. M.
 W. Getler *101*
Women by the Sea (1970) 50 × 40, Harmon
 Gallery, Naples, Florida *60*
Storm Clouds (1970) 32 × 40, Dr. and Mrs. Robert
 E. Carroll *102*
Carnival of Sails (1971) 60 × 56, The
 Pennsylvania Academy of the Fine Arts *103*
Wind in October (1971) 40 × 50, Artist's
 collection *104*

The Steps (1971) 66 × 53, Artist's collection *61*
Shadows on the Beach (1971) 60 × 48, Artist's
 collection *62*
The Sea at Lehinch (1972) 50 × 40, Artist's
 collection *113*
Ophelia (1972) 56 × 46, Artist's collection *114*
Shadows on the Rock (1972) 60 × 54, Alexander
 Hale and Evelyna Hale *115*
Landscape by the Sea (1972) 60 × 54, Private
 collection *116*
Wind Over the Sea (1973) 56 × 50, Artist's
 collection *63*
Edge of the Park (1974) 50 × 40, Artist's
 collection *117*
The Wreck Near the Driftwood Cove (1974) 50 ×
 56, Artist's collection *118*
The Sea at Night (1974) 56 × 50, Artist's
 collection *119*
Moonlight by the Sea (1974) 60 × 56, Artist's
 collection *64*
Clock and Candlesticks (1974) 48 × 60, Harmon
 Gallery, Naples, Florida *120*
Lightning and Storm (1974) 62 × 56, Robert
 Beverly Hale and Niké Hale *105*
House on the Park (1974) 40 × 50, Artist's
 collection *121*
Sculptor's Head (1974) 50 × 40, Artist's
 collection *122*
Still Life with Granite Head (1974) 48 × 60,
 Artist's collection *123*
The Sparkling Sea (1975) 56 × 50, Private
 collection *124*
Meeting of Land and Sea (1975) 62 × 56, Artist's
 collection *106*
Night on the Edge of Town (1975) 50 × 40, Artist's
 collection *107*
The Great Wind Over Land and Sea (1976) 66 ×
 60, Frank E. Taplin *108*
Morning Fog (1976) 66 × 60, Artist's
 collection *109*
Sails on Dark Water (1976) 54 × 60, Private
 collection *110*
The Seashore—II (1976) 48 × 60, Artist's
 collection *111*
The Beach Near St. Tropez (1976) 60 × 48,
 Artist's collection *112*

Notes *125*

Selected Bibliography *125*

Chronology *127*

One-man exhibitions *127*

Index *128*

I have agreed to write some personal words about Balcomb Greene and the authors of this book not merely because they are all friends of mine but because they have done so much to enrich the cultural life of our time.

Balcomb Greene's career has not been like that of the ordinary artist. Nor does he look like the popular image of the artist. He is tall and rangy, radiating health and restless energy. His interests, from his youth on, have been not only in art but in philosophy, psychology and poetry. As the authors relate, he started, like his father, as a preacher but soon became a writer and taught English literature at Dartmouth College. Art, however, was in his system; he always found time to sketch; and he had the good sense to marry an artist and go to Paris with her to study art intensively. He wound up in New York City as a professional painter and soon became recognized as one of the leading American abstractionists. He was also their most eloquent champion against the pro-European classical bias of the American museums and critics during the '30s and '40s. He was the first chairman of American Abstract Artists, and one of the first editors of their magazine, for which he designed some of the covers. But he was too creative to confine himself to any one school. He experimented with representational painting, and his later work branched out into new and profoundly original forms as shown in the following pages.

No one could have been found more qualified than the Hales to write about him. For many years Robert Beverly Hale was the curator of American painting and sculpture at the Metropolitan Museum of Art. He was responsible for recommending to the trustees for purchase the best products of contemporary American art. A large portion of the Metropolitan's great collection in this field consists of works chosen by him. He is of course well known as an artist as well as an author. His writings include a superb book on *Drawing Lessons from the Great Masters*, which many laymen like myself have found endlessly rewarding. He has also taught multitudes of students at Columbia University and at the Art Students League, who will long remember him with gratitude and affection. And no wonder, for his charm, humor and warmth have endeared this gifted man to all who have had the privilege of knowing him.

His talented wife, Niké Hale, is a Vassar graduate, with a master's degree and a doctorate from New York University. She has taught at Pratt Institute and the Art Students League, and has written many articles on art history. She is a handsome and endearing person, of Greek parentage. Her father, George Mylonas, is a famous archaeologist. She and her husband and their two young children spend their summers on the enchanting quiet island of Hydra, where I once had the good fortune to set foot.

This book is the first—and let us hope not the last—of their literary collaborations.

—*Lloyd K. Garrison*

Balcomb Greene

Balcomb Greene's early years reveal the strange detours that many a man experiences before the eventual mastery of his art. Born in Millville, New York on May 22, 1904, the son of a Methodist minister, he was christened John Wesley, in honor of the founder of Methodism. As a child he kept the beliefs of his father; in later years, having become critical of all religious sects, he changed the formal John Wesley to Balcomb, his grandmother's surname.

His father, Bertram Greene, was educated at Ohio Wesleyan, and after receiving a Ph.D. degree in history from Ohio State University, left the east, the supposed center of intellectual fervor in the 1900's, and took his family to live in Iowa. He followed the Methodist policy that "you had to shake up ministers, keep them moving from town to town in case they got too familiar with one parish." Conscientious and liberal for his day, he preached to the simple congregations of the rural west, often complaining about having to move so much and occasionally wishing he had been a Presbyterian. To his wife, Florence, raised in upstate New York in the sophisticated circle of the Stover family, life in the west was hardly congenial. Her father was the supervisor of an Indian reservation, her sister a writer of short stories, and this new environment seemed the essence of parochialism.

Florence Stover Greene died when her three children were very young. The two little girls were sent to live with their Aunt Mary Stover. The boy stayed with his father, who followed the circuit of the Methodist Church, living a harsh and frugal life. Intellectual and compassionate in his religious views, and far too liberal for the Church, his father was a pacifist and preached socialism from the pulpit. In the early Twenties he was expelled from the Church. He returned to upstate New York and sent his son to high school at Findley's Lake, a lake "about as big as a room and full of mud," as Balcomb described it. Bertram Greene in later years resented the Church, but when an old friend intervened in his behalf, he agreed to return to the ministry.

The boy went to Syracuse University on a scholarship provided for the sons of Methodist ministers, intending, despite his father's disillusionment and disapproval, to preach. While still at college he preached in a small rural church for ten dollars a sermon, and like his socialist father, he felt a strong sympathy for the poorer farmers. He slowly broke away from the church, and in 1926 received a B.A. in philosophy.

Though the Greenes as a family had been close to the church, they also had a strong secular side. Descended from the revolutionary hero, General Nathanael Greene, they felt a smug pride in their past as well as a conservative urge to forget the radical impulses of the American Revolution. Rooted in a tradition that included both state and church, Balcomb Greene later wrote, "the Church cannot be arrogant, the State only pretends to be. For arrogance or for independence, one must seek, as at all chaotic moments, in the individual."[1]

At college, he became acquainted with a few writers and artists and responded to their ideal of individual expression. An admirer of Joseph Conrad, he became interested in literature. "I wrote furiously," he has said, and tried to develop a personal style. In New York on Easter holiday while wandering through the Metropolitan Museum, he had met Gertrude Glass, a young and attractive sculptor, and as soon as he received his degree that year, rushed back from Syracuse to New York City to find her. The daughter of Jewish refugees from Latvia, she was studying at the Leonardo da Vinci School where classes were given by a group of highly conservative teachers on the top floors of an Italian church on Tompkins Square. She spent three years at the school, witnessed the opposition by the conservative artists of the day to the new art from Paris, and joined in the debate between old-fashioned realism and the new abstraction that had split the artists into two hostile camps. Despite their conservative training, several artists were progressive in their outlook and it was this radical abstract group that she followed. Greene met many of her fellow artists who supported the new art; he studied philosophy, filled notebooks with his own writing, read the interesting new ideas of psychology published by Freud in Vienna. He thought it was time to leave America.

Balcomb and Gertrude were married in 1926, left for Paris and travelled to Vienna where he attended a series of lectures on psychology and wrote articles for a dictionary of psychology being published in Holland. "In my innocence I thought I'd meet Freud and we'd become friends," he has said, amused by his earnest youthful ambitions to study with the master whom, as it turned out, he met only once.

The following winter the Greenes returned to Tompkins Square and he enrolled at Columbia University to study for an M.A. degree in English literature. He took one course in creative writing but, discouraged by its narrow view of writing for royalties in the commercial market, he never took another of that sort. While he was working on his M.A. dissertation, "The Fallen Woman in 17th Century English Literature", his old advisor left Columbia and when the new advisor disapproved of "Fallen Woman" Greene wondered whether he should finish his degree at all. He applied for a job at Dartmouth College. Two professors came down to see him, liked the dissertation, liked Greene, and hired him on the spot.

From 1928 to 1931 he taught English Literature at Dartmouth, lectured on the novel, wrote his own novels and finished three before he got his first bid from a publisher. By then the depression had deepened into reality and the publisher promptly went bankrupt.

Greene left Dartmouth in 1931 and travelled with Gertrude to Paris, back to Montparnasse, where in a courtyard on the Rue Bardinet he rented a small studio whose bed was so tiny that he slept with one foot on the floor to keep from falling out. He wrote on the balcony and sometimes joined Gertrude and painted in the studio. During the winter, he worked at the atelier of the Académie de la Grande Chaumière.

Foreign students who could not pass the strict language exams at the prestigious Ecole des Beaux Arts were attracted by the methods of the ateliers where the Beaux Arts professors came by and criticized the work. By the 1930's the ateliers had become small, sympathetic retreats for artists who wanted no supervision, no controlled or exact standards imposed upon their work. They saw the cubist revolution grow and fade; they saw Dada explode

and the followers of Tristan Tzara flood Paris; they heard André Breton's manifesto and the portentous words of the Surrealists. The Ecole des Beaux Arts seemed centuries away. The experiments in painting attacked every academic rule and young artists flocked to Paris where the modern tradition of Picasso and Matisse radiated an irresistible glow.

Greene sketched at the Académie de la Grande Chaumière, but received no criticism: It cost more money and he didn't have it. He continued to work at his writing, met Stanislaw Grabowski, part musician, part artist, who became his close friend, and it was about Grabowski that he wrote "The Poet":

> *When young in Paris*
> *learning to paint,*
> *briefly I knew well*
> *Stanislaw Grabowski.*
>
> *a handsome and outrageous painter*
> *who sold women's stockings*
> *in cafes*
> *and often at night*
>
> *played his piano*
> *alone in a small cold room*
> *with fingers he heated in water,*
> *music sad like his wonderful paintings.*

Stanislaw stated:
"Painting and music make you nothing but sadness and loneliness, like a requiem."

> *But the stockings he sold*
> *he sometimes drew gently*
> *over her naked legs in his room,*
> *"Up to her bottom," he said*
> *"and in front is life."*

When Gertrude and he came back to New York in 1932, Greene realized that his true interest was painting. Writing became less absorbing. For a time he worked on the newspapers, *Broadway Brevities* and *Graft*, both quite terrible and noted mainly for their exposure of private and political crimes and drawings of nude girls. It was not long before he left the newspaper trade to work for the Emily Francis Contemporary Gallery, a non-profit organization that showed particular interest in American artists and had exhibited the work of Bradley Tomlin and Mark Tobey.

Greene developed the basic structure of his work in those early years of the Thirties. He kept tight control over his interest both in the figure and in abstraction, what he has called his "straight line, flat paintings." Feeling that he did not understand the figure very well, he attended sketch classes in various artists' studios on 14th Street, drew from the model, and painted it with oil on paper. At the same time he worked on the composition of his abstract painting, subsequently referred to as "off-beat purist" in *Art News*.[2] In 1941

much of this work was destroyed by fire in his studio. Greene walked in, saw the devastation, reached for a cigarette, tried to find a light and walked out again. Still, enough pictures survived to show the abrupt force and excitement of his early career. Though he frequently did the figure, recent critics looking back to the Thirties usually refer to his abstract work.

Greene's ability to experiment and invent is abundant in his early paintings. He believed that all sorts of ideas should be entertained, and freely discarded, and followed the new experiments in American abstract art. He tended to reject the more fashionable European art. His poem "Congressmen-Flower-Clench", published in the *Partisan Review*, begins: *Much which has happened to me is of small significance and much which I think about has no meaning because I am that sort of a man in 1937. I am close to forty, it was said yesterday by a congressman and by some small fry of a poet that death begins at forty. For an American*.[3] While dismissing the imposing and accepted European art of the day, he was sharpening the rebellious edge of his imaginative wit.

The young abstract artists in New York lacked the affluence and publicity of their contemporaries in Europe. To buy the audacious modern paintings Americans at the time travelled to Europe. Contemporary museums preferred to show European pictures. In 1936, when the Museum of Modern Art held its impressive "Cubists and Abstract Exhibition", the majority of the work was European. In 1938 the Museum of Modern Art, claiming it lacked sufficient space, refused to exhibit the work of the Society of American Abstract Artists.[4] In 1939 and 1940 the Museum again refused to hold the show of the American Abstract Artists. Francis Henry Taylor bluntly explained the attitude of the Thirties. "Because of the magnificently organized 'racket' of the School of Paris in the post-war boom, which monopolized the New York market, he [the American artist] has been forced to paint for a period of ten years jumping from one trick to another in order to meet the competition from abroad."[5]

The abstract artists in New York also suffered from the realistic trend in the work of the popular and frequently imitated American painters called "regionalists," who believed that their realistic style effectively opposed abstract art. As early as 1929 the critic Royal Cortissoz described a contemporary show in the *New York Herald Tribune* in this fashion: "All the familiar names are represented, beginning with Picasso and Matisse and not forgetting Modigliani, but we cannot say that the familiar mannerisms of these individuals are rendered any more persuasive to us . . . We have found nothing in the show to mitigate the prevalent atmosphere of blague and technical incompetence."[6] As the prolific spokesman of the regionalists, Thomas Hart Benton believed American art should reflect the American scene, and wrote that the regionalists first wanted "a dissolution of the contemporary ban on the stressing of the subject matter."[7] Presumably the day of abstract art was over, the return to realism the accepted course. The European Cubists and Surrealists, who had held their first group exhibition in Paris in 1925, were part of the past.

Though small in number, the enthusiasts of abstract art held their own exhibitions. A.E. Gallatin's Gallery of Living Art at New York University opened in 1927, the Museum of Modern Art opened in 1929; many German artists arrived in New York in the early Thirties, bringing the ideas of the pedagogical Bauhaus that had long nourished abstract art in training and practice. After the Bauhaus was closed in Germany in 1933 its members began to

arrive in the United States. Moholy-Nagy founded a new Bauhaus in Chicago in 1937. Lyonel Feininger landed in New York. Hans Hofmann came and started the Hofmann School on 8th Street in New York. Josef Albers founded Black Mountain College. And in 1937 the Museum of Non-Objective Art began its exhibitions of abstract artists.

The new galleries were ambitious but small. The young abstract artists were seldom asked to exhibit and decided it was time to form an independent society of their own. In 1935 several met in the studio of Rosaline Bengelsdorf and discussed the possibility of forming a cooperative society.[8] A year later, Balcomb and Gertrude Greene joined them in Ibram Lassaw's studio. In 1937 a general meeting brought more artists together, and it laid the ground for the formal organization of the American Abstract Artists. Greene was elected its first chairman and elected again in 1939 and 1941. He helped to write the charter of the society, and later wrote the charter of the Federation of Modern Painters and Sculptors, both groups intended solely to help the artists rather than to support political ideals. Gertrude Greene was in charge of the early exhibitions of the American Abstract Artists.

The charter of the American Abstract Artists (AAA) was printed in each copy of their magazine:

"Our purpose is to unite abstract artists residing in the United States, to bring before the public their individual works, and in every possible way foster public appreciation for this direction in painting and sculpture. We believe that a new art form has been established which is definite enough in character to demand this united effort. This art is to be distinguished from those efforts characterized by expressionism, realistic representation, surrealism etc.

"We recognize the need for individuals to experiment and deviate at times from what may seem established directions. For this reason we place a liberal interpretation upon the word 'abstract.' What we desire is a broad inclusive organization of all artists in this country who have produced work sufficiently in character with this liberal conception."

The purpose of the AAA reflected not only the interest but the new confidence of the abstract artists, and led the way for subsequent artists to join together, if not in formal groups, at least in attitude, to oppose the established art of the galleries and museums. It stated clearly that abstract artists no longer accept the arbitrary division between American realism and European abstraction. The division it formed between experiments and conventions in art was a logical one, based on judgment rather than on geography. In 1939 Balcomb Greene wrote in the magazine of the AAA: "Abstract art arrives as the first international language of the brush."[9]

Aside from serving as the chairman of the AAA, he helped edit the magazine. Kept strictly in the hands of the artists, editorial chores were assumed by Carl Holty, Harry Holtzman, Ibram Lassaw, Charles G. Shaw, Warren Wheelock, and Greene, who in 1938 designed the cover of the magazine. Having worked previously on *Art Front*, the magazine of the Artists' Union and drawn the magazine cover in 1936, he was no novice at the task. He designed a pattern of diagonal planes which formed the basis for the printed blocks of copy. Similar to his painting of 1936, *Abstraction II*, diagonal planes carry the weight of the image, defying the measured distance of a secure and clear horizon and maintaining their own balance.

In the late Thirties his work changed. In designing the cover for the

magazine *AAA* in 1938, he devised a strict pattern of one vertical line and one horizontal. The lines divide and hold the space of the picture in neat, separate areas. The horizontal, not directly in the center of the picture, suggests a distant horizon, which crosses the vertical and ties down the design. It refutes the equivocal mood of the earlier *Abstraction II* (1936), insisting rather on a new geometry, of an impersonal and neat precision.

His study of the geometric and abstract forms ran alongside his early study of the figure. In painting the figure, *Oil on Paper* in 1936, he expressed a compassion and dignity. Agile, but certain in his belief, he walked a tightrope, never in danger of losing balance or falling into overstatement, oversentimentality, or just plain vulgarity. He perceived the human paradox. The figure in his painting is free in its gesture, yet bound to the world, confident of its strength though restricted by black shadows that lighten its weight, the solidity of its mass. The room is pervaded by a bewildering sense of space. Greene did not describe it, did not explain it; he held the figure, a distant and private spirit, in the tenuous moment of an ambiguous dream.

Simultaneously he developed the precision of his abstract style. In the painting previously referred to, *Abstraction II*, he measured and clarified the space of the picture. Dismissing traditional methods of perspective, he defined the space by tilting a series of planes; nothing was vague, nothing left to chance. Transmuting the tenuous spirit of the figure into sharp outline of geometric form, he was seeking a private geometry, exploring a statement of visual and personal memory. He no longer expected traditional perspective to make explicit weight, mass and space in his picture, and geometry renders spatial illusion in his work, an evocation of rest rather than action, of permanence rather than the transitory.

Through these years, he pursued the rebellion of the abstract artists, writing in 1938: "It is actually the artist, and only he, who is equipped for approaching the individual directly. The abstract artist can approach man through the most immediate of aesthetic experiences, touching below consciousness and the veneer of attitudes, contacting the whole ego rather than the ego on the defensive. There is nothing in his amorphous and geometric forms, and nothing within the unconscious or within memory from which he improvises, which is deceptive. The experience is under its own auspices. To whatever extent it helps reconstruct the individual by enabling him to relive important experiences in his past—to that extent it prevents any outward retrogression."[10]

Fighting the realist art of local sentiment, folklore, and indigenous virtue, he led the protest of the AAA during those years of his group activities, opposing also the art imitative of European abstraction. He supported the radical beliefs of the AAA and edited in 1938 the society's yearbook that formally answered critical opposition to abstract art. In the previous year, 1937, the society had held the first show of its 39 members, probably the best attended show of American abstract art outside a major museum.[11] Of this show, the critic of the *World-Telegram* wrote: "We had not known until now that there was a broad contemporary revolt against literary subject painting."[12] And the critic of *The New York Times* said: "The American public is far more interested and would like to see more of it than anyone had hitherto suspected."[13] In 1938 the society held its second show at the Fine Arts Gallery in New York. Again the exhibit was a success, the number of visitors well over 7,000.[14] A year later the AAA reached a new peak of excitement. It found good reason to attack the

rather pious premise of the Museum of Modern Art, which in 1939 presented its impressive exhibition: "Art in our Time." It reached back fifty years to the work of LaFarge, Homer and Sargent, and showed the work of Picasso and Léger, along with other artists living in Paris. The paintings of the young American abstract artists were ignored. The members of the AAA were clearly disappointed. When in 1940 the Museum of Modern Art exhibited drawings and cartoons from the newspaper *P. M.*, the members of the AAA protested. On the opening night of the show they distributed, in front of the Museum, a broadside titled "How Modern is the Museum of Modern Art?" designed by Ad Reinhardt. A member of the Museum staff saw it, promptly declared it a proper piece of art, and was said to have bought up the remaining sheets.[15] But the point was made. The most progressive museum of contemporary art in New York was ignoring American abstract art.

Soon after its successful attack on the Museum of Modern Art, Greene left the AAA as well as other groups of the Thirties which he had once joined eagerly. He had also worked in the government's Works Progress Administration, had designed a mural for the WPA in the Federal Hall of Medicine at the World's Fair in 1939, a mural for the Williamsburg Housing Project, and a stained glass window for the Bronx School of Arts and Science. It was when the purpose of the AAA seemed to him to have been fulfilled that Greene resigned. He began to study for an M.A. degree in the history of art at New York University. While finishing his dissertation, "Mechanistic Tendencies in Painting 1901-08," he abruptly left New York—the various groups of artists he had known, the debates, the doubtful politics—to teach at Carnegie Tech in Pittsburgh, where he stayed for seventeen years, returning frequently because his wife kept a studio and worked in New York. His job in Pittsburgh was not a retreat for him, but he no longer participated in the rebellions nourished by groups of artists. After 1942 he worked alone.

Of his work in the early Forties, he said: "I thought complete abstraction in art was a dead end." He felt that his earlier painting had successfully solved the problems he had confronted in his abstract style; it had achieved the regularity, the balance, the clarity, of geometric design. But his work of the Forties fought the very purpose he had himself originally devised. It broke the mould of abstract art, the impassive, still air of its design, the rigid shapes of geometric form. It sought analogy in nature; opened out to the light and space of natural form. It took on the sporadic excitement of natural, unpredictable action. Restless in mood, it approached an ambitious hope, charged by intimate response. It turned on a wide, free belief in the spirit of nature revealed by rocks, by land, inevitably the ocean. In essence Greene set his own conditions.

Years later, in his paintings of the Sixties, Greene explained the obsessive riddle held for him by the land and the ocean, always the line of the horizon marked clear beyond the waters. In one stanza of his poem "Distant Shore" he wrote:

> *I dreamed that it rained*
> *by the sea forever*
> *with birds frozen like a painting*
> *in the black sky*
> *the wind a tune of endless repetition,*
> *nothing in sight could move.*

My feet plunged wildly on a distant shore,
naked to reach them
I ran.

Greene has said, "When you paint nature, you realize how humble you are, how dependent on it you are." In the early Forties he was cautious, even timid, in his painting. His description of nature was careful. He tried to see where he could start and started in a simple way. He painted the line of the horizon. In *Blue Space*, 1941, he did not turn against his earlier style, and yet he was working out a new idea. He saw his abstract design tied to the horizon, pulled down to the simplest, most obvious line in nature, the clear break of land and sky.

Slowly he joined the sophisticated moulds of abstract design to an evolving idea of nature. In *Composition*, 1940, a geometric form lies on the edge of the horizon; another floats above the sky. Again, in *Monument in Yellow*, 1941, he depicts a geometric form at the horizon. The form, divided into the neat units of abstraction, began subtly to suggest the general block of a figure.

With growing confidence in his sense of land and sky dividing his world, he turned to the figure. Landscape tends to be more abstract than the figure. He knew the difficulties. "When you get too abstract things are sterile," he said. Abandoning the fragile air of his earlier abstract designs, he painted *The Cry* in 1947 and *Execution* in 1948. He looked at the 19th century paintings of Edvard Munch and Edouard Manet, and expressed an affirmation, a respect for traditional art. He described the brutal pain of a man; if the land in Greene's painting is serene, the man is broken, the light burns him away. Persistently inquisitive, when Greene painted a landscape he sought a basic form, and discovered the simple line of the horizon. In painting the figure, he again searched out a basic expression. He discerned the pain of a man, and hewed to it integrally from beginning to end.

Greene proceeded to consider a new and curiously complex idea, referring to Manet's *Olympia* in 1951. He had previously separated his pictures of the land from those of the figure. Here he attempted a partial combination. Olympia lies down, she rests on the earth. She strikes a definite pose. The light, rather than distorting, holds her in an embrace close to the land. The classic tale is transformed: the mythological god no longer supports the giant ball of the earth. The classic Olympia rests on its surface.

In 1953 Greene painted *Figure Lost in the Light*, and again the figure rests on the land. If consumed by light, she resists a brutal distortion. The bright spots of light, rather like a carnival, surround and support and hold her close to the land.

Greene found two basic attitudes in his figures. Seldom painting directly from the model, he has said, "I like to see the nude moving around, rather than posed, to get the feeling of the figure in my head." In his study of the figure he did not stress anatomical shape but rather its intuitive, often conflicting spirit. He painted two different figures. And one stays close to the land, serene and secure; the other drifts in the circle of an individual sorrow.

Immersed in expression of private grief, he painted, in 1958, the portrait *Gertrude IV* as a round globe of a head, massive, distant, far from the horizon, remote from any resting place. The land is finite in its absolute state of measures and weights. The figure freed from the land imparts an infinite sadness. Greene returned to this theme in his later work in the Seventies: *Ophelia* in

1972; *The Sea at Lehinch*, 1972; *House on the Park*, 1974. Ambiguity hovers about the forms. The figures resemble the busts of classical portraits. Indifferent to measures of time and space, they convey an illusion of ancient and distant remorse.

Greene worked alone in Pittsburgh during the Forties and Fifties but kept some connections in New York. The Museum of Modern Art bought his painting *Execution* in 1948. The Guggenheim Museum had previously bought his work. In 1950 he held a one-man show at the Bertha Schaefer Gallery in New York, considered by *Art News* to be one of the year's ten best exhibitions. On one of his frequent trips east, he bought land at Montauk Point on Long Island and with the help of his wife Gertrude built a house on a cliff above the ocean.

Though determined to pursue his solitary style, Greene was of course familiar with the work of the artists of the times and of the movement of the Abstract Expressionists, who were then strongly encouraged by the many French painters living in New York. Peggy Guggenheim, a devotee of French Surrealism, opened the gallery, Art of this Century, in 1942. That same year Pierre Matisse held the show "Artists in Exile." André Breton, the French spokesman of Surrealism, lent a hand to the young American artists and, along with the surrealist painter Max Ernst, advised the editors of the art magazine *VVV*. Opposing pure abstraction, Surrealism had a strong psychological flavor, and was characterized by difficult technology and terminology. Breton, originally trained as a psychologist, wrote explanations of the current psychological beliefs. If the style of his new painting often followed modes of earlier abstract art, the action of the artist, his psychological expression and creative process, assumed a new interest.

Greene did not join the artists bent on personal interpretation. Despite his initial interest in the work of Freud and his early studies in Vienna, he said: "I never believed in personal style. In the Thirties I wanted to be impersonal. Didn't sign my work, didn't like the artistic ego. Never made a self-portrait." He criticized the new interest in the individual image of the artist, the personal aspect of genius, "an antiquated notion of genius," he called it. In "The Fourth Illusion, or Hunger for Genius," written in 1951, he said: "It is the illusion that people who become involved in creating art are not people."[16] In the 19th century, "the genius concept implied that art may be useless, but that its maker is Divine."[17] He insisted on the prime importance of the work of art itself.

"A picture is painted of modern art that arranges all participants into movements, like well-behaved Englishmen in clubs," he wrote.[18] He thought it a useless task. "The concept of an 'art movement' (as distinct from an artists' group) presumes a helpful transmission of stylistic elements between contemporaries. It is difficult to show that artists involved in a movement either gain or lose from the esprit-de-corps and the small borrowing of devices."[19] Greene showed no interest in joining a new movement when he resigned from the AAA in 1942. The beliefs of a movement disappear soon or late, paintings remain. Indifferent to the specific activities of a group of artists, Greene also saw no reason to develop a specific program for teaching artists. Despite his student days at the Académie de la Grand Chaumière, he had trained himself, chiefly by the discipline of his work. In the seventeen years that he taught at Carnegie Tech he never held a regular painting class there, teaching the history of art and aesthetics. However, he taught painting for a short time at the Irene

Kaufmann Settlement House and at the City Art Center in Pittsburgh. In 1968 Greene published "Basic Concepts for Teaching Art". "The controversy over art education arises from a broader controversy. Art specialists do not agree as to what art is," he wrote and implied ironically that if the specialists could agree, the artists would surely follow.[20] He attacked the general notion that art can be defined by concepts, explained by reasons or taught to "flesh-and-blood students." Critical of educators, he attacked their encroachment on the territory of the artists. "The concepts governing art education should not be borrowed. Largely they have been. They have been borrowed from the general educator—the man who has characterized himself as an exponent of liberal education." He attacked any educational system based on one aesthetic standard, one rule or accepted approach and insisted on the importance of an artist's independent work. He wrote in *Art News*, 1956, "the view of teaching which I consider positive is . . . that one who breaks conventions must teach."[21]

Greene exhibited his paintings regularly. As early as 1932 he held a one-man show in Paris; in 1947 he exhibited at J.B. Neumann's New Art Circle in New York and at the Arts and Crafts Center in Pittsburgh; and it was in 1949 at the Bertha Schaefer Gallery that he caught the attention of the critics. *Art News* wrote of his show there in 1952: "Recent paintings continue to recreate human form and action on the artist's own dramatic terms of voracious light and shade."[22] Again, of his 1956 exhibition, *Art News* said: "Balcomb Greene is having possibly his best show in a career which included his election in 1937 to the first presidency of the American Abstract Artists . . . The ghosts of the future are invading his villa. These extraordinary, often terrifying figures, mouldering into fire and surf, floor the mood with associated ideas. Shadows are now ready to break from their bones."[23] Of his retrospective exhibition at the Whitney Museum of American Art in 1961, John I.H. Baur, former director of the Whitney, wrote: "[He] is, above all, an intuitive painter who will not be bound even by his own concepts . . . In one form or another he will continue to explore the deep inner springs of mind and emotion that make man what he is."[24]

By the time Greene joined the Saidenberg Gallery in New York in the early Sixties, important museums, notably the Metropolitan, the Whitney, the Museum of Modern Art and the Guggenheim, already owned his work. Noted collectors, among them Joseph Hirshhorn, Roy Neuberger and J.M. Kaplan, bought his paintings. *Art News* said in 1962: "Stating his vision with naturalness that makes the world 'style' seem too contrived, he has left behind any limitations of the studio situation, the props and the model, to enlarge the experience and its scope. . . ."[25]

In every new exhibition, critics found excitement and power. Malcolm Preston wrote in *The Christian Science Monitor*, 1973, "Greene's got it all together now . . . loneliness, ineffectiveness and anxiousness are his major themes. And these he evokes by means of large scale figures—blurred, diffused and unclear—as though seen through flickering veils of light. He infuses his surface with vitality and energy. The bigness of his figures heightens their static-heroic aspect and by alternation, concealing and revealing forms and details, he suggests a fleeting mortality. By distorting, blurring and often misshapening his images, he sees man as anguished and brutalized by forces he is unable to combat."[26] Emily Genauer wrote that he has "come to the figure—and beautifully . . . [They] have a spectral quality, but this has to do with their

powerful emotional impact, not their firm controlled structural substance. This is distinguished, extremely individual painting by one of the country's best artists."[27]

Greene worked continually, developing, through the Fifties and Sixties, the precise elements of an astute and disciplined belief. He limited his subjects. They fell into a natural order, a series on the figure, on the land, and another on the ocean, each an expression of his sensual, intuitive trust in nature. He has said: "Cézanne gave us the answer in practice . . . Constantly he derived the truth, the correct accent, the solidity and scale from nature . . ."[28] Greene's painting expressed a wide, discerning view of nature and its operative force. As if working on one continuous canvas, he painted the figure and the land and the ocean over and over again. He distilled his belief, trying to find the exact point where nature reflected its erratic, violent power.

He had from his early days painted the figure in one form or another, and often returned to his unresolved approach, studying, describing, restless, inquisitive, observant, analyzing the figure in various groups of paintings in which, though each implied a different spirit and condition, Greene saw the figure as alone, isolated in time.

He painted several pictures of his wife in the late Fifties. He wrote, with his old friend Grabowski in mind, "I have learned no less, perhaps more, from the woman I married."[29] Gertrude Greene died in 1956. He painted *Gertrude IV* in 1958, seeking to render the honest faith, the grace of a strong sensibility, painting the head of a woman caught by a shadow which clings to her like a shroud—utter sorrow. She has no background, no base, no connection to the rational dimensions of a circumscribed world. Perceiving the depth of her spirit, he depicted her arrested in a moment of time and alone.

Greene then turned to find the point of balance between one being and another, the place where they meet and join before taking separate paths. In *The Parade*, 1961, he inscribes the woman intent on her own private drama while she stands next to a man on the street. As if by accident before they turn away, they touch in brief and in unbroken silence.

That same year he began a large group of pictures describing the crowds of the city streets. Particularly concerned here with the relation of figure to background, he tried to connect the figure "to the environment thematically as well as compositionally." He had previously studied this relation and often in his earlier work had cut out the figure and tried it on different backgrounds. But he now considered the background as more than simple design. He sensed it as a reflection of an imposed and restricted world, a world constructed by man, understood and survived by man. Living in Paris at the time with his present wife, Terry Trimpen, he often photographed the city he so much loves. He wrote the poem "Paris":

> *Her streets are the veins of love*
> *and her avenues*
> *by the Baron's command*
> *the arteries of hate.*
>
> *On the boulevards*
> *there is a confrontation*
> *of all brilliant people*
> *and at night*

they are mixed
in intimacies the light forbids
and the gendarmes flee
and the streets echo
to the impossible crimes
and the delicious vices
like children laughing in the Luxembourg
their hearts all sweetness and behavior

Laughing at the sewers beneath the street
at the dying nun
at the professor being born
at the Metro on rubber tires

which follows the sewers
through the city
so that people,
villains and lovers of darkness,

can go to work at daybreak
as the city planned,
riding the one,
or floating on the other.

Assuming that people enjoy a gregarious life, Greene watched the crowds in the city. In *Boulevard St. Michel* in 1965, he painted the people on the street as seemingly indifferent to each other. Resuming the order of his earlier abstract style in *Two Figures* in 1966, he devised a stern pattern of lines and shapes, in which the figures join, like pieces fixed in a puzzle. They characterize the directions of the city, its methods, its autonomous rule. He then achieved an alternate view. The rigid grid of the city fades, the figures emerge, the condition of strain is relieved, the woman of *Le Pont Neuf* (1967) walks alone, asserting the core of her identity. Greene painted many of these city scenes, searching always the point where people merge their loneliness. He saw it at first as the accident of a superficial moment, imposed by the nature of city life. Later he described it as an instinct, brought into reality by the character of a human being.

Greene considered a distinct and different group of figures when in 1970 he painted *Women by the Sea*. He followed the response of the figures to each other, the openness of their mutual faith. Soft and sensual in mood, the women reflect a pure white light as if bathed in the white spray of the sea. They share a private, inherent trust. Free from the public life of the city, they feel no disorder, no conflict between their desires and the natural rhythm of the sea.

Greene has said, "I do not believe that art should be explicit. It should be suggestive and ambiguous . . ."[30] He has often described the conflicting spirit of the figure that refutes an exact and rational theory. The figure presumes implicit, imaginative trust; if the structure of nature is not explained its power is intuitively sensed, and communicated. When he painted his pictures of the sea Greene realized the equivocal essence of nature more completely. He realized its complexity, its wide range reflecting perpetual force and limited boundary.

Despite the present critical belief that Greene has been mainly a painter of the sea, he did not consider it until the late Fifties. He had first developed the sophisticated style of his early abstractions. It was in 1947 that he was attracted to the sea, and if it became his most forceful and persistent theme, he approached it only during the past seventeen years or so.

He regarded the sea "as more abstract than people." Resuming his earlier abstract style, he saw the line of the horizon as "a means of anchoring down the picture," but he no longer considered it of fundamental importance in a geometric design. In *The Fog* in 1965 he suggested the line of the horizon by the slight tone of a white light, but the fog hides its precise direction. The diagonal sweep of rock disturbs its balance, subdues the sea as the oppressive fog turns it white and indefinite, a white hole in the distance of a sublime nature.

He has said, "boats are apt to be too pretty," but even if wary of the subject, he painted the boats of *North Sea*, 1968—like an improbable collage. He saw them removed from the lay of the land; inevitably following the rhythm of the waters, they lose their solid form, they merge in the broken light and the depth of an unknown space in the sea, and in the sphere of the artist's imaginative world of nature.

Greene defied the austerity of a definite line or a fixed point in nature. In *The Enormous Wave* of 1964, the sea is bound by the rigid line of sky and land, but at midpoint the lines break as if strained beyond control. The sea abandons passivity. Turning in sharp waves it hides the straight line of the sky, it destroys the edge of the land, it asserts the solitude created by its power.

If puzzled by the division of land from sea, and obsessed by the edge where they touch, Greene later saw the unity of its design, suggesting its presence in *Maine* (1965), and *Shadows on the Rocks* (1972). The sea repeats the shape of the rocks. It reflects the permanent solidity of land; and implies a controlled assimilation of the forces of sea and earth.

In his early painting Greene expressed the conflict between figures, and in his abstractions particularly concentrated on the division, the edge, the contrast between lines, between abstract shapes. Greene began to join these contrasts in his work in the Fifties. In *Sails and Dark Water* (1976) the white light does not divide the land from the sea but rather suggests a movement, a union of fragile action and constant time. He saw the forms of nature, he described them, but he dismissed the dichotomy of spiritual essence and measured form. He described a classic unity, removed from the precision of a mathematical design, a unity in which the forms of nature contain opposing conditions. The movement of sea and solidity of land join. The operative control and permanent mass create a constant state. The intuitive grasp of imagination holds the measure of an earthly world.

—Robert Beverly Hale and Niké Hale

The Plates

1936 *Art Front* magazine cover 25

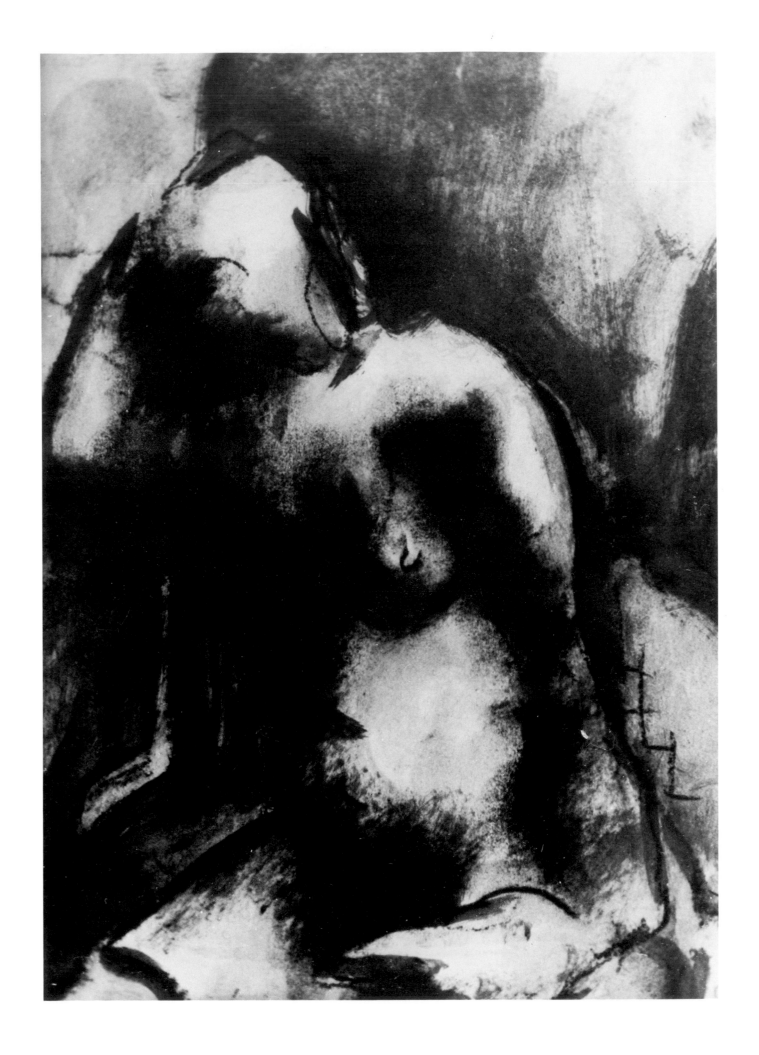

26 1936 Oil on paper

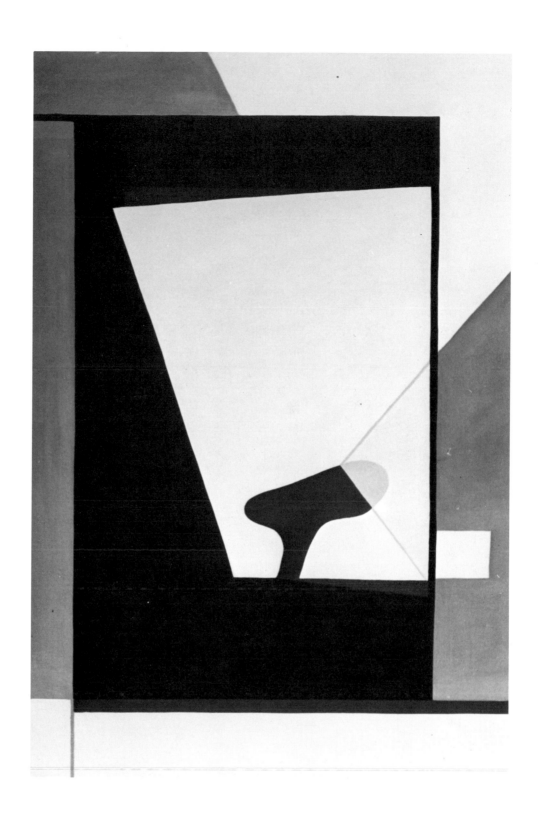

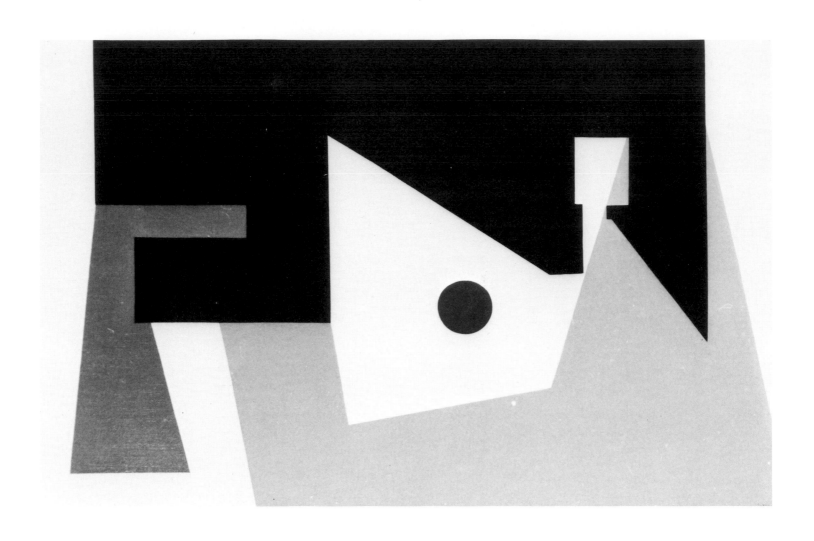

28 1936 Composition

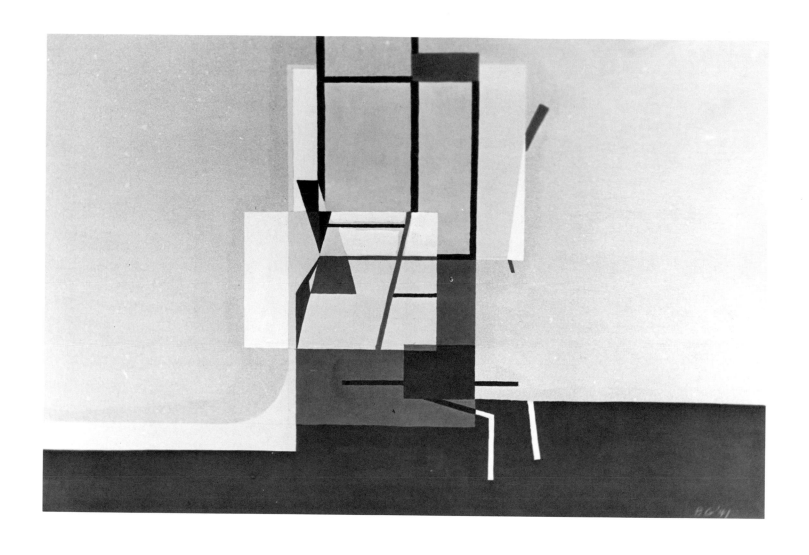

1941 Monument in Yellow 29

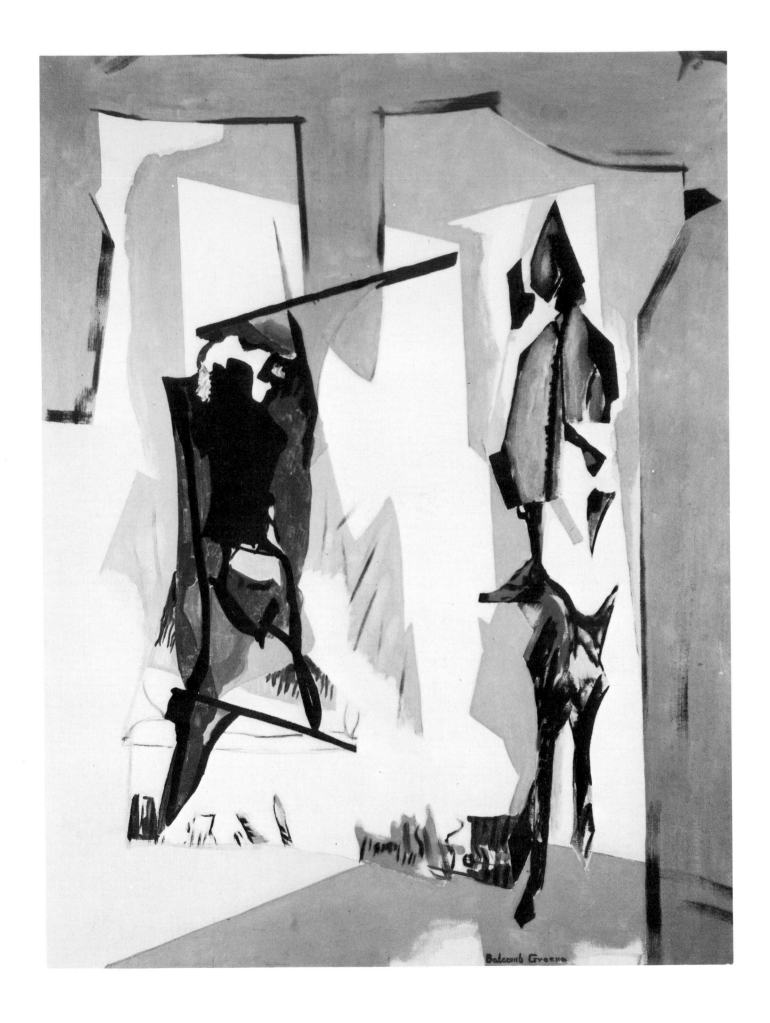

Balcomb Greene

30 1947 The Cry

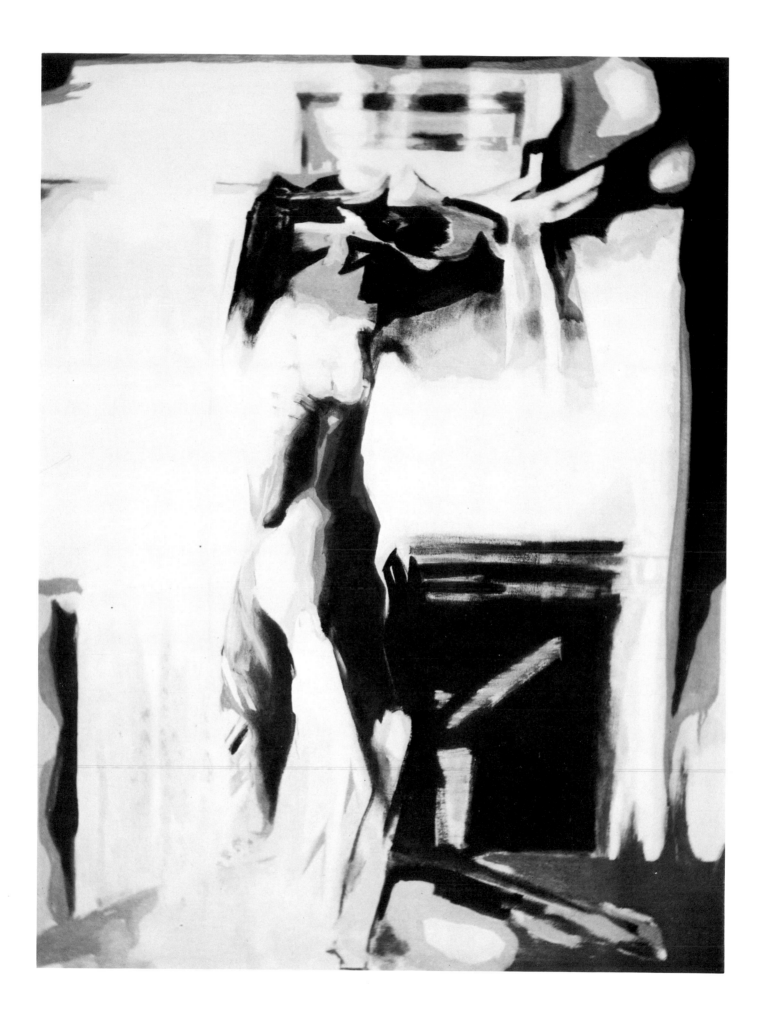

1948 The Execution I *31*

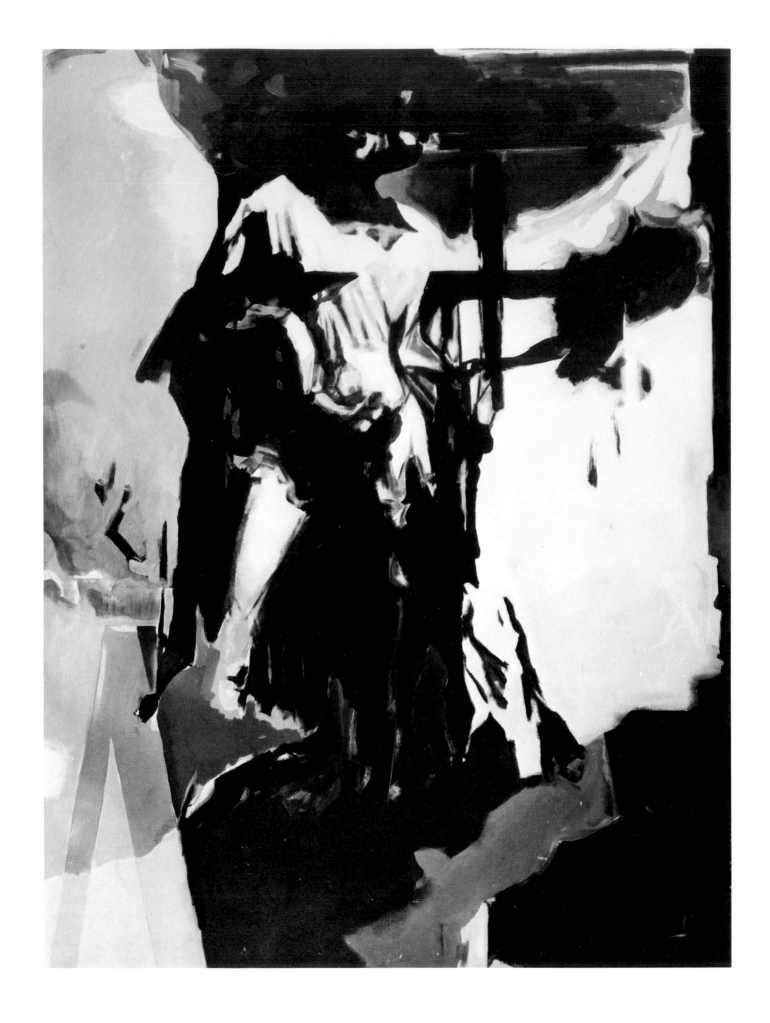

32 1949 The Tragic Actor

AMERICAN ABSTRACT ARTISTS

PAINTINGS CONSTRUCTIONS SCULPTURES RELIEFS ESSAYS COLLAGE GOUACHE WATERCOLOUR PAPIER COLLE PAINTINGS CONSTRU

1938

1938 *American Abstract Artists* cover 33

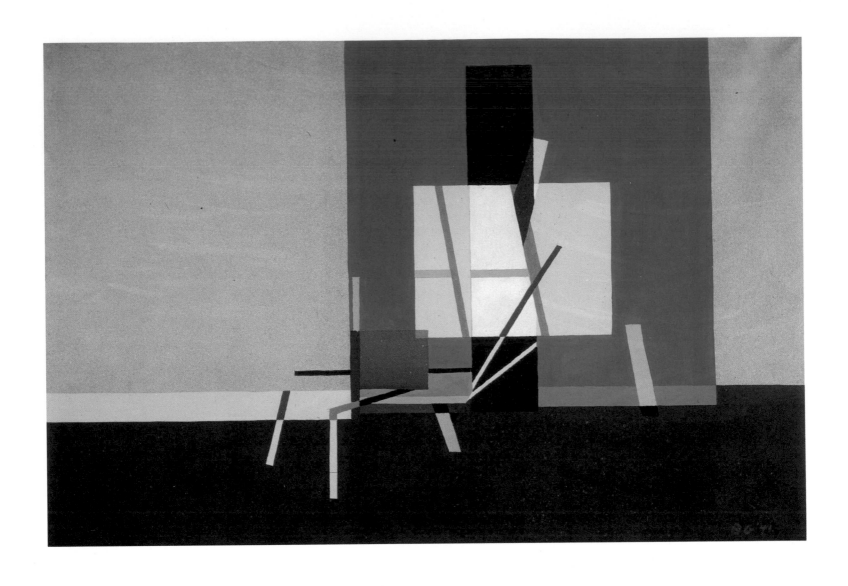

34 1941 Blue Space

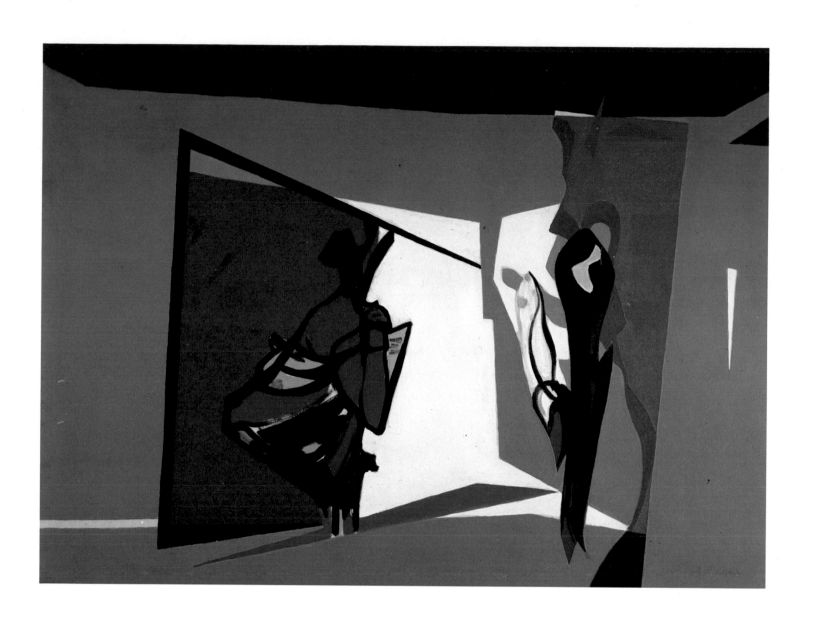

1945 A Scene from Molière *35*

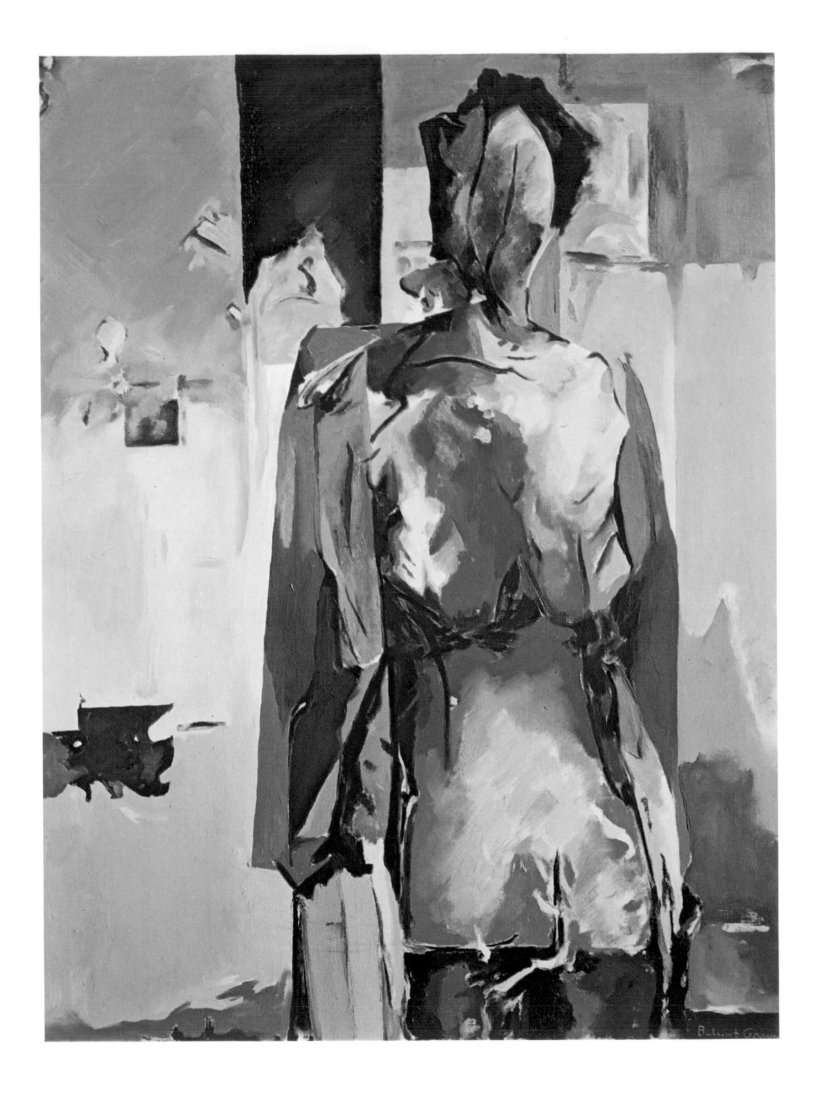

36 1949 Waiting Figure

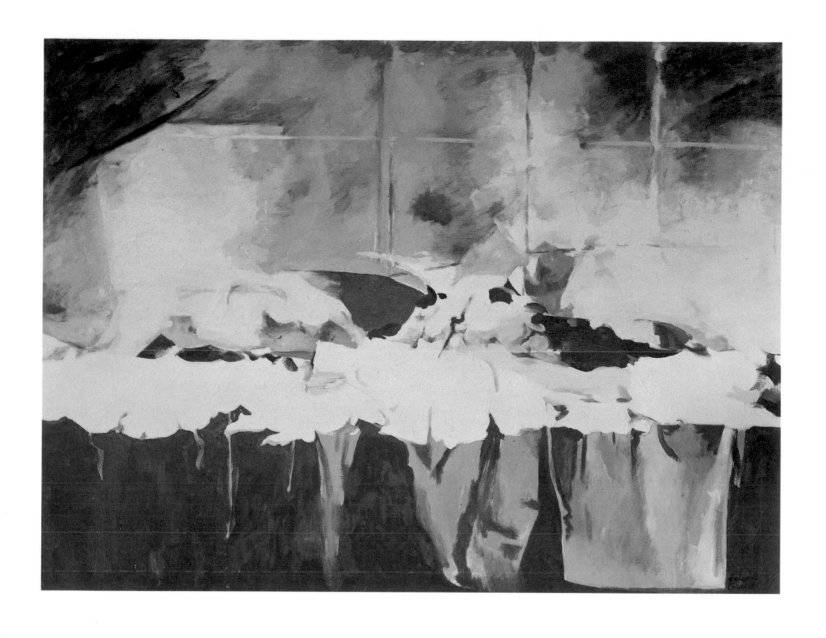

1953 Figure Lost in the Light 37

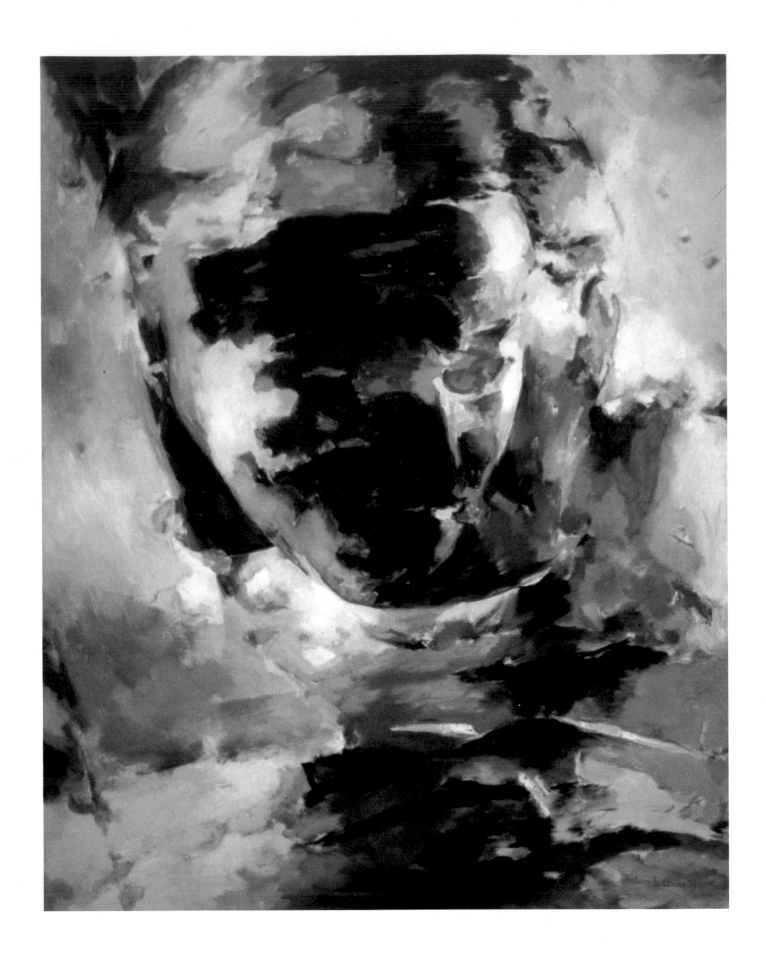

38 1958 Gertrude III

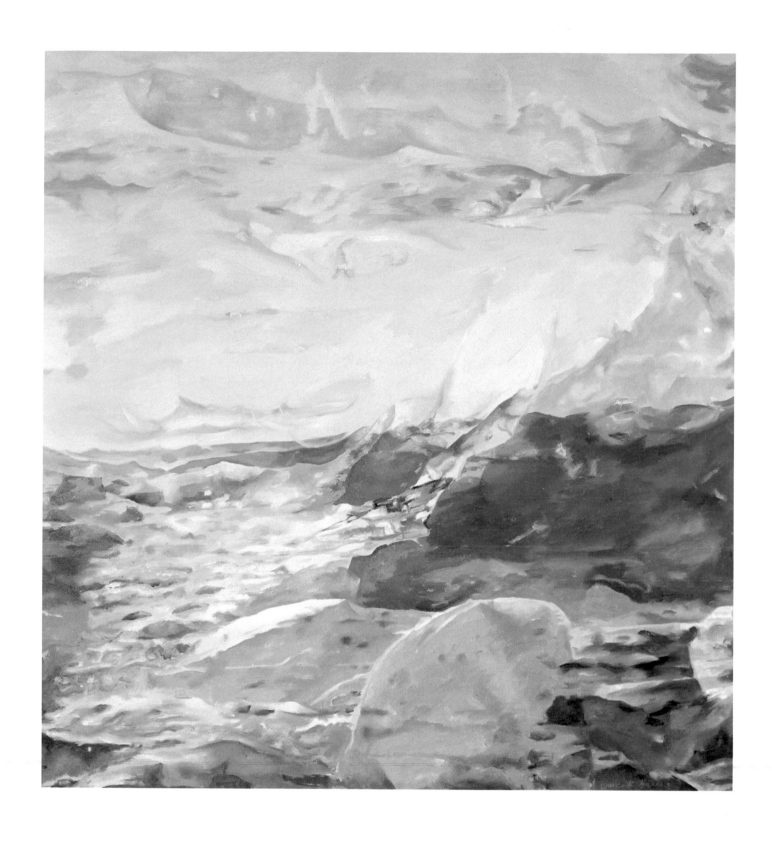

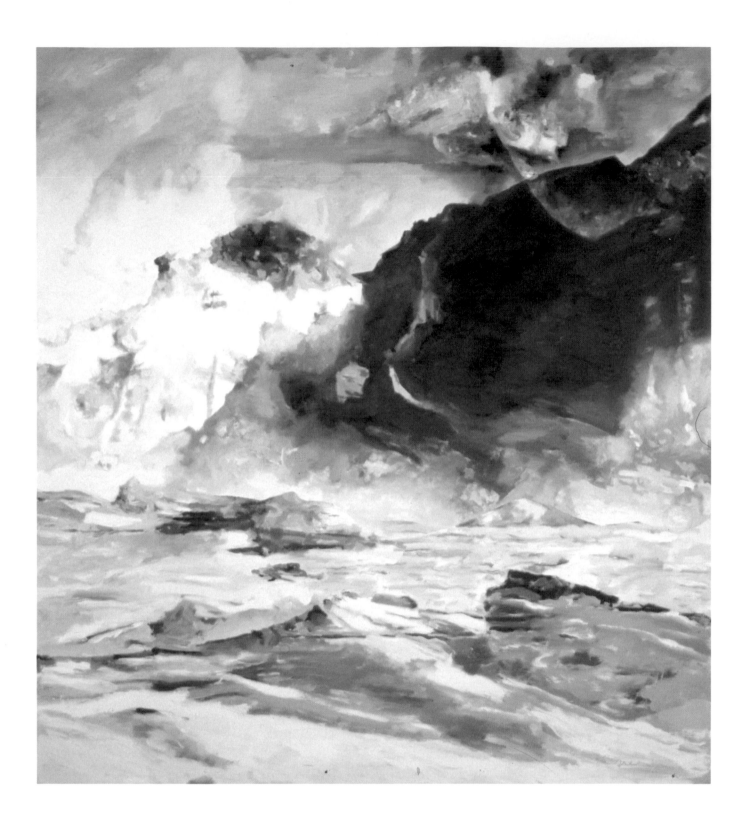

40 1965 The Cliffs Near Montauk Point

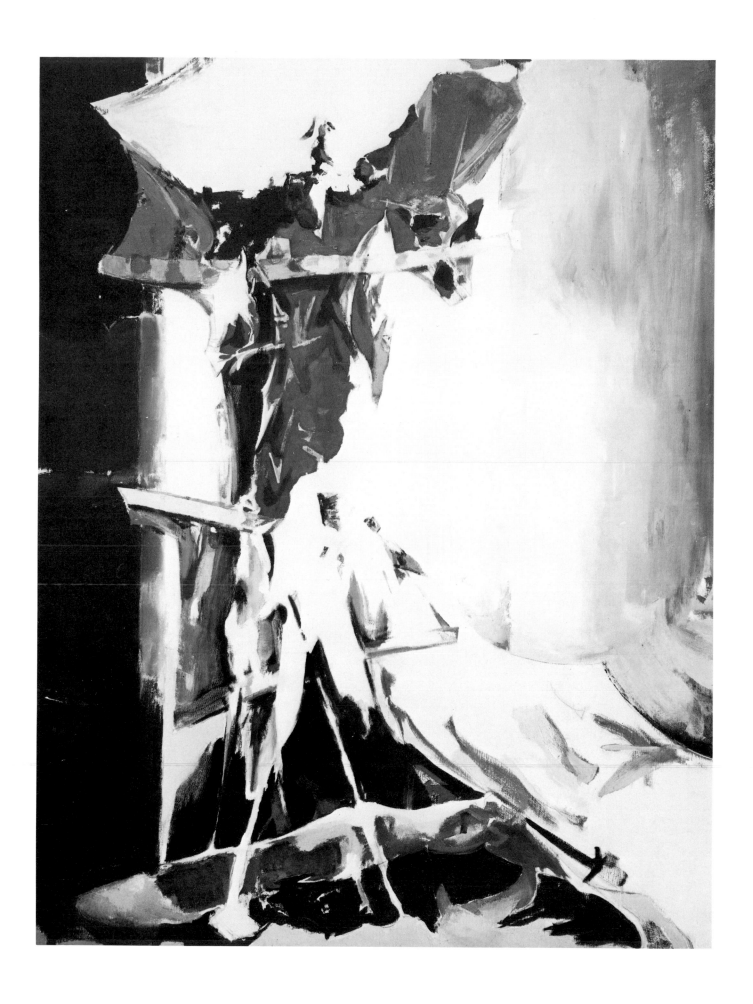

1951 Apparition 41

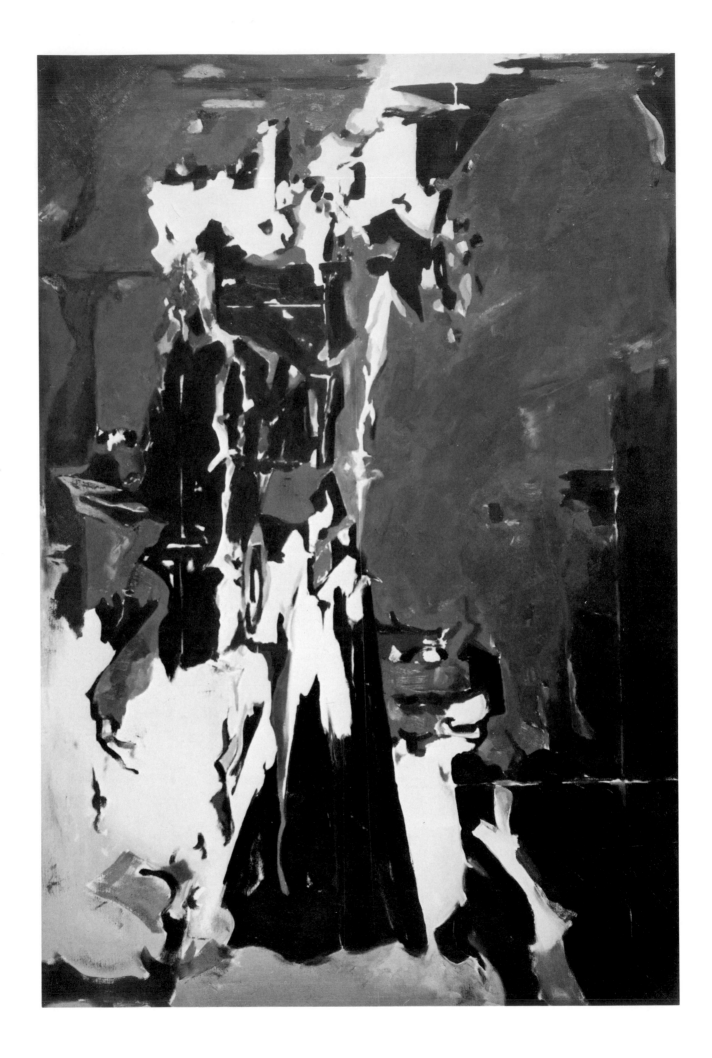

1951 Abstraction—Figures

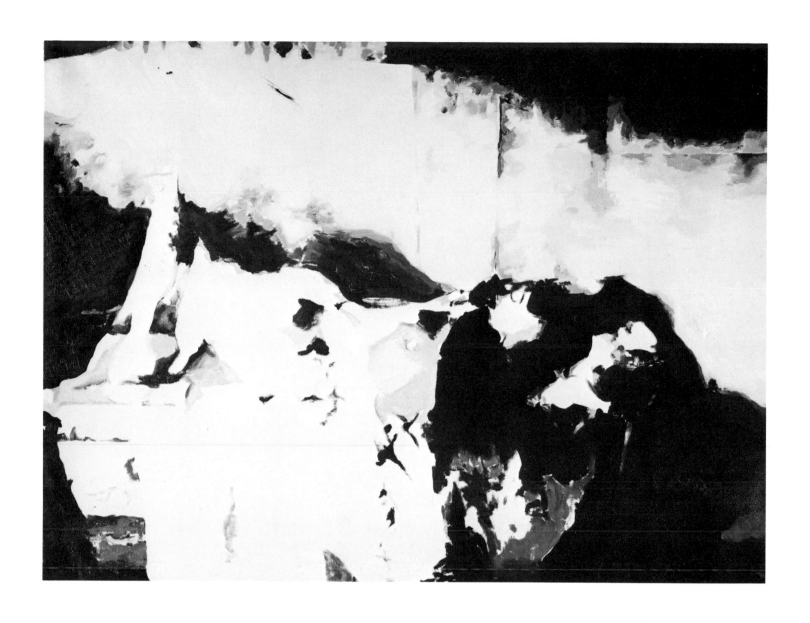

1951 Olympia 43

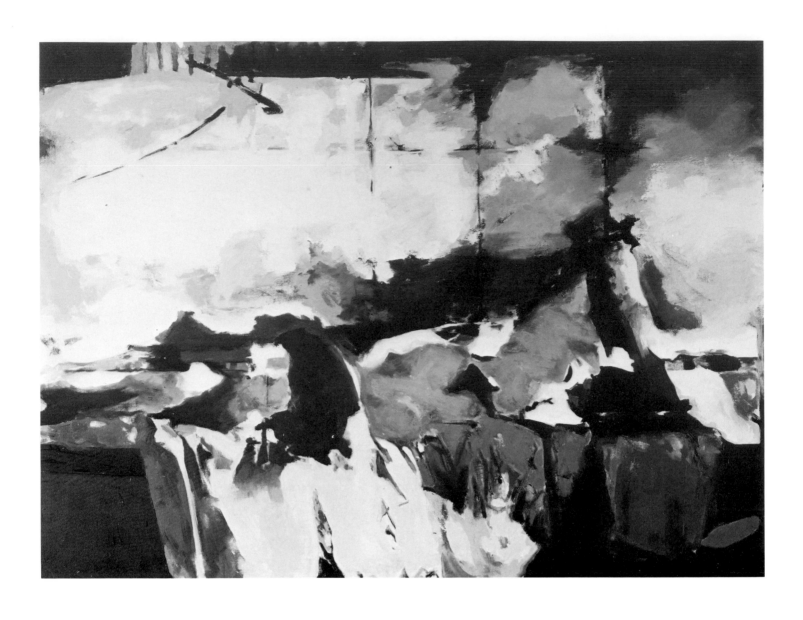

44 1952 Nude in Yellow Ochre

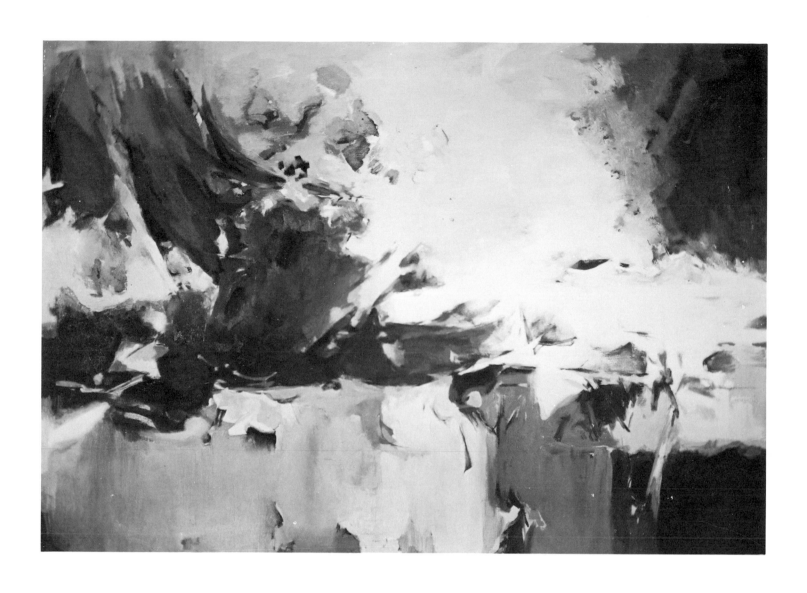

1952 The Flag 45

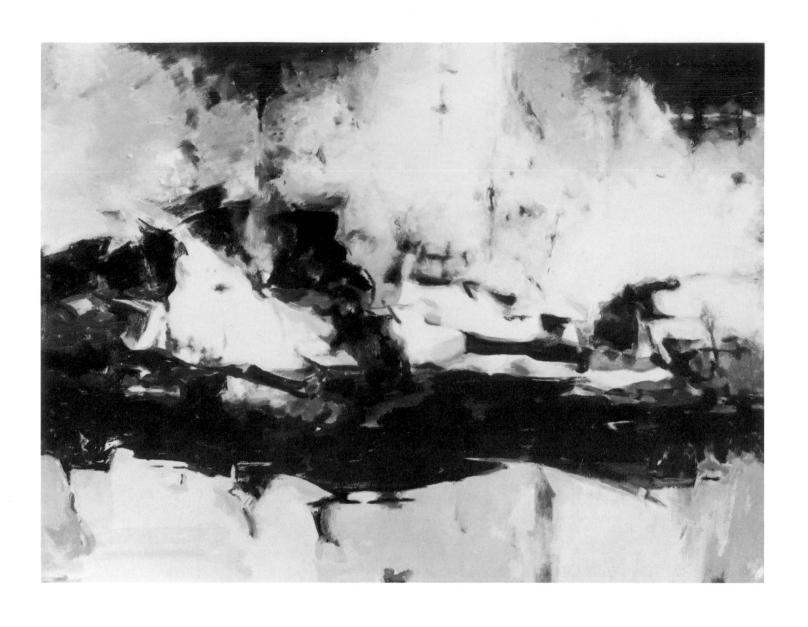

46 1954 Composition—The Storm

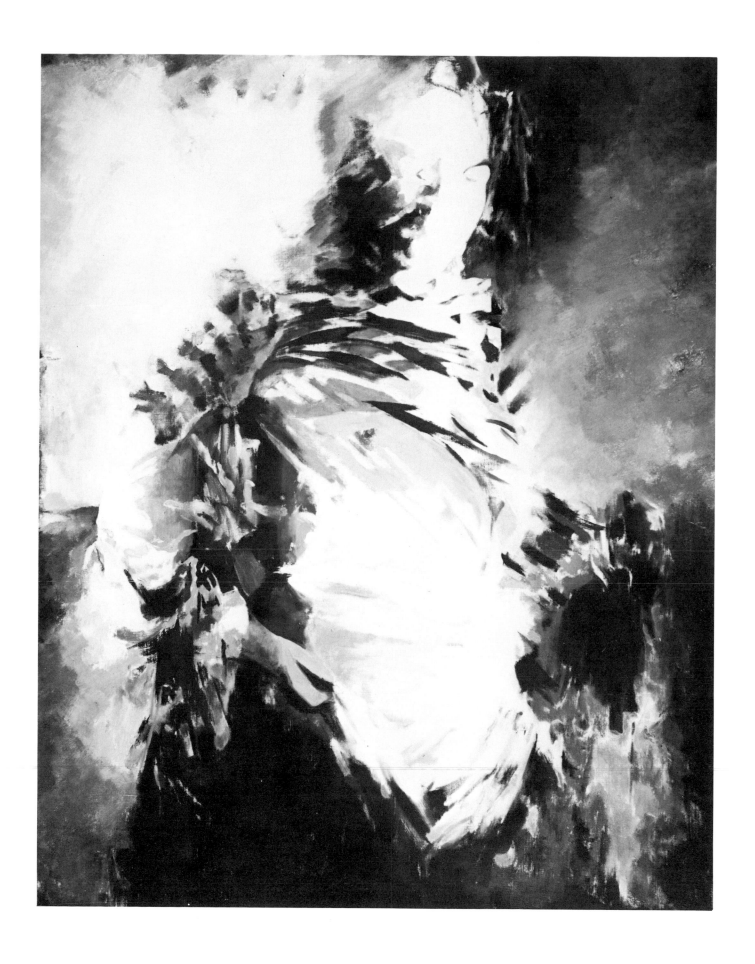

1955 Woman Dressing 47

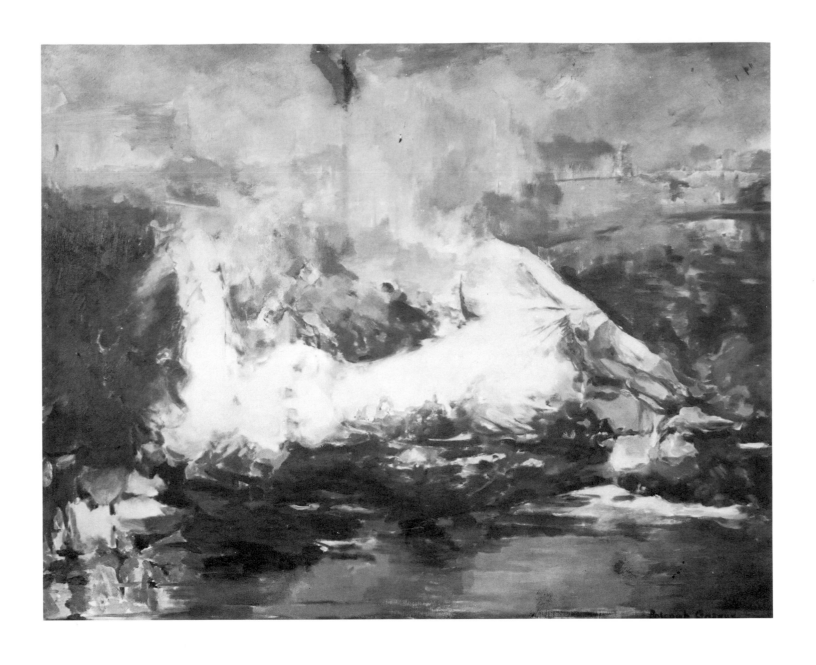

48 1956 Anguish

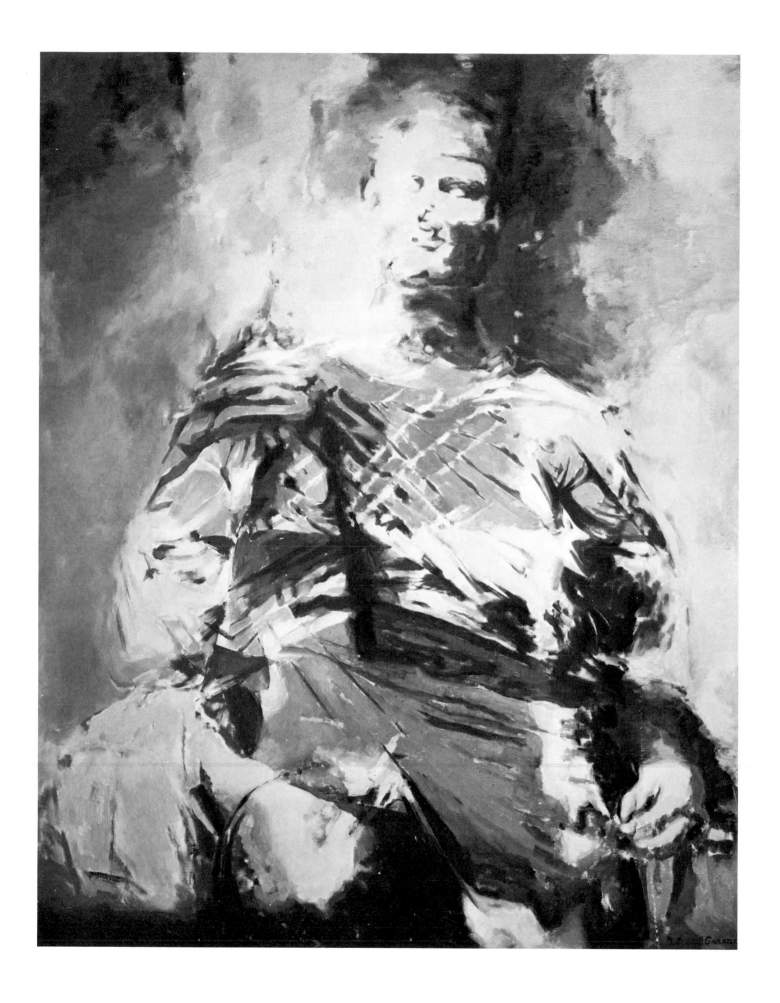

1956 Seated Figure *49*

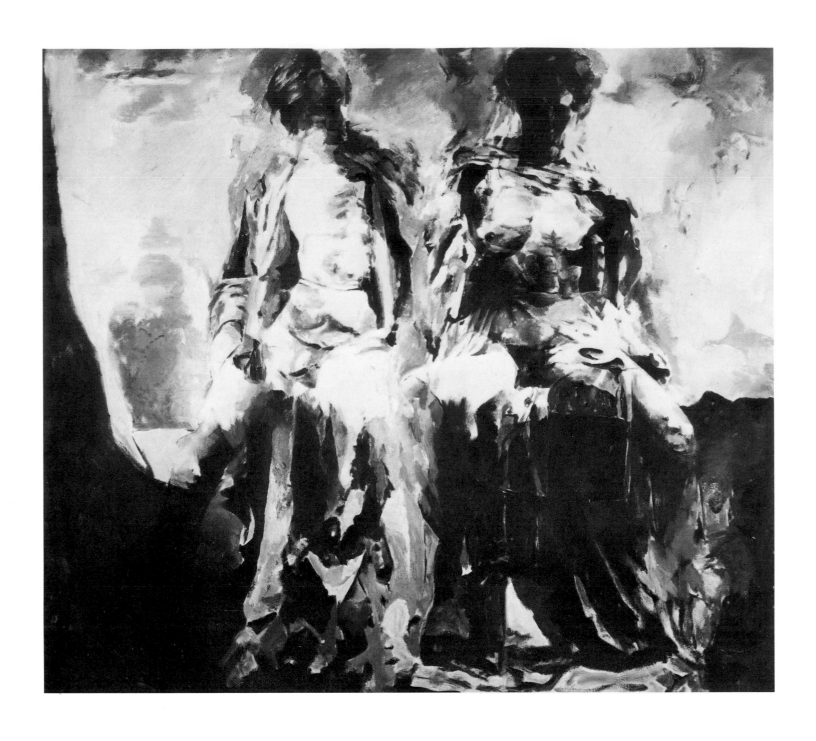

50 1957 Seated Figures

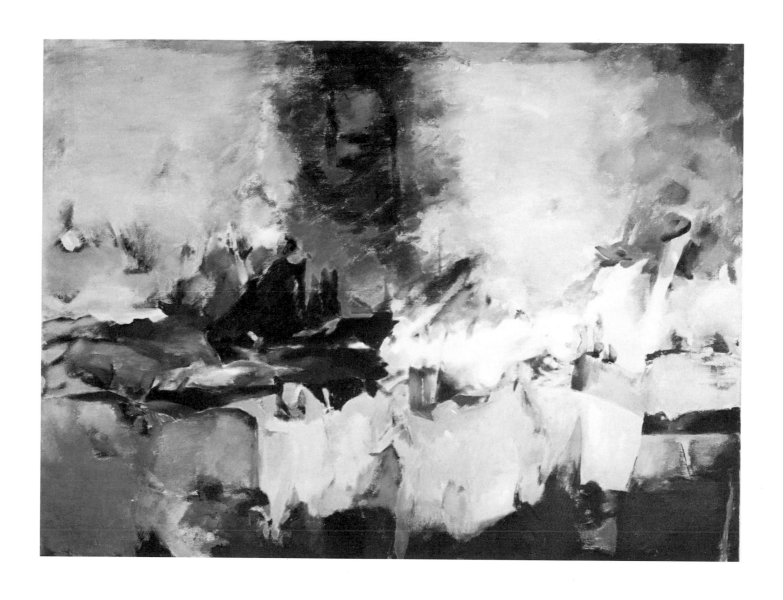

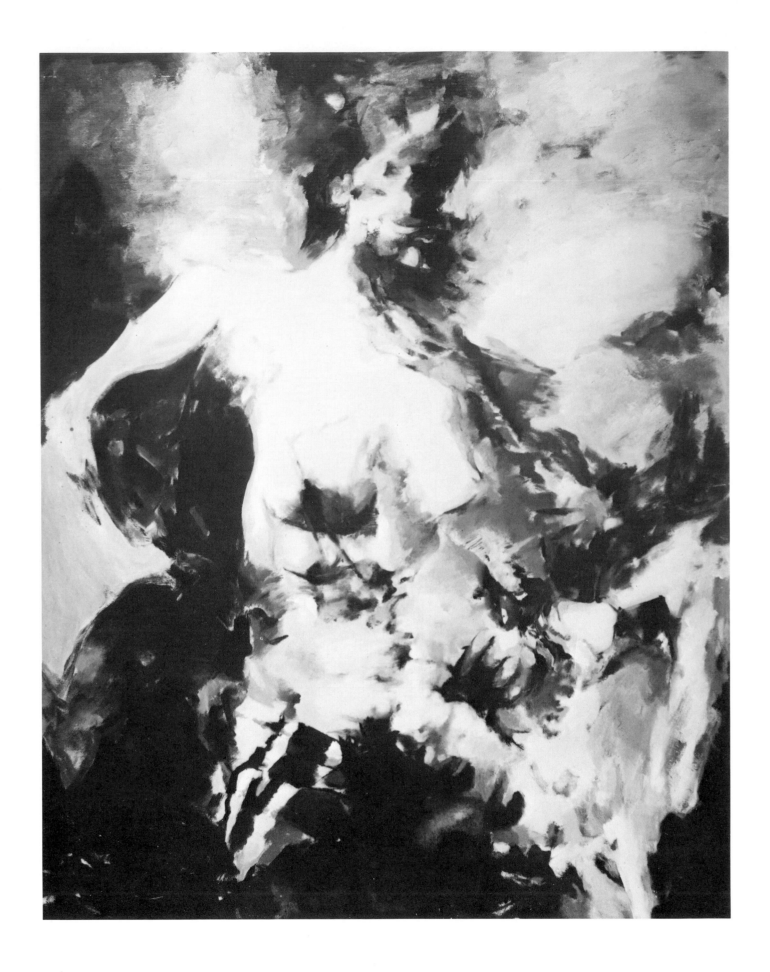

52 1958 Gertrude II

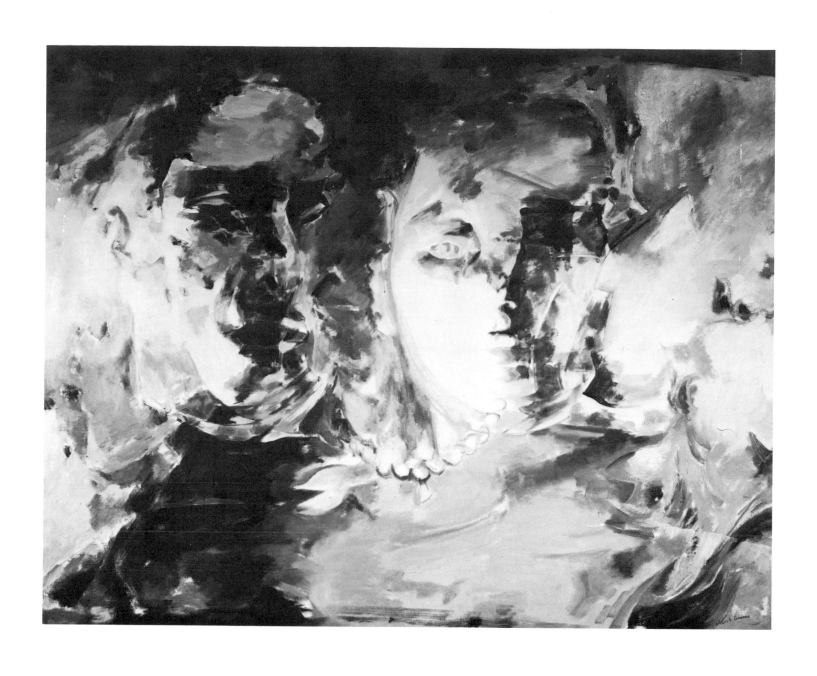

1958 Double Portrait 53

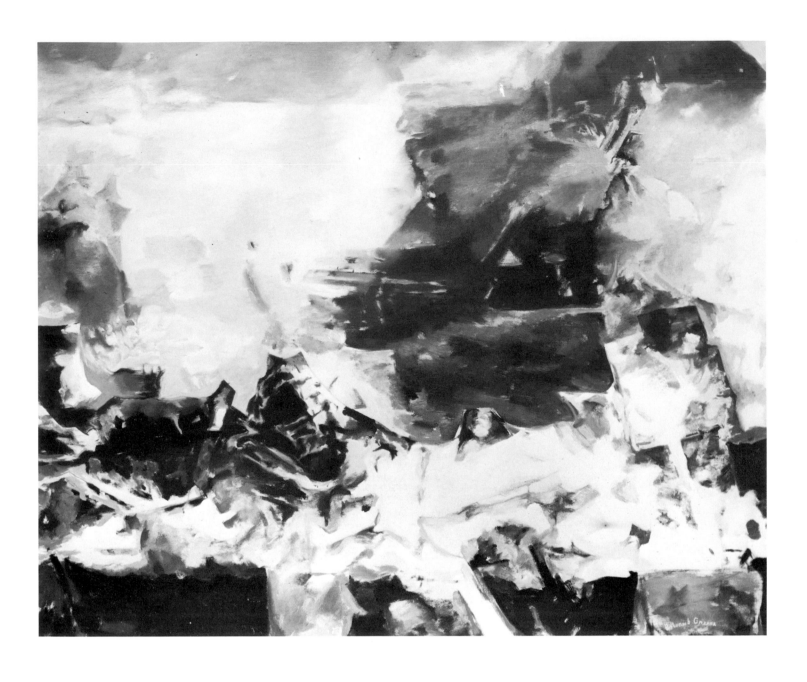

54 1958 Abstraction—Storm

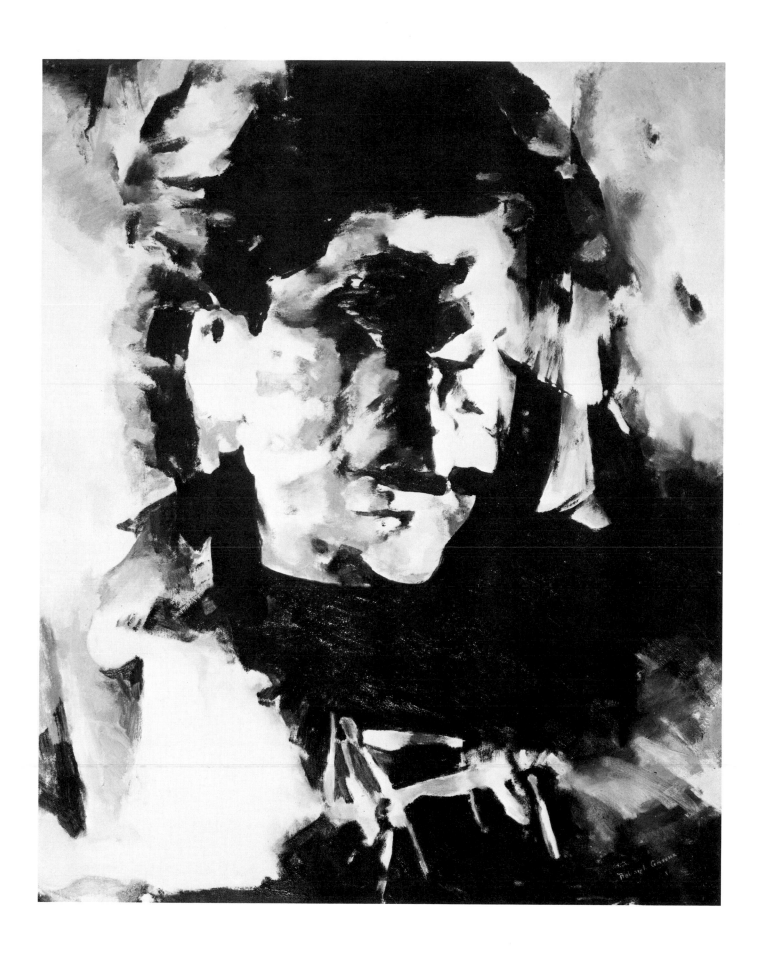

1958 Gertrude IV 55

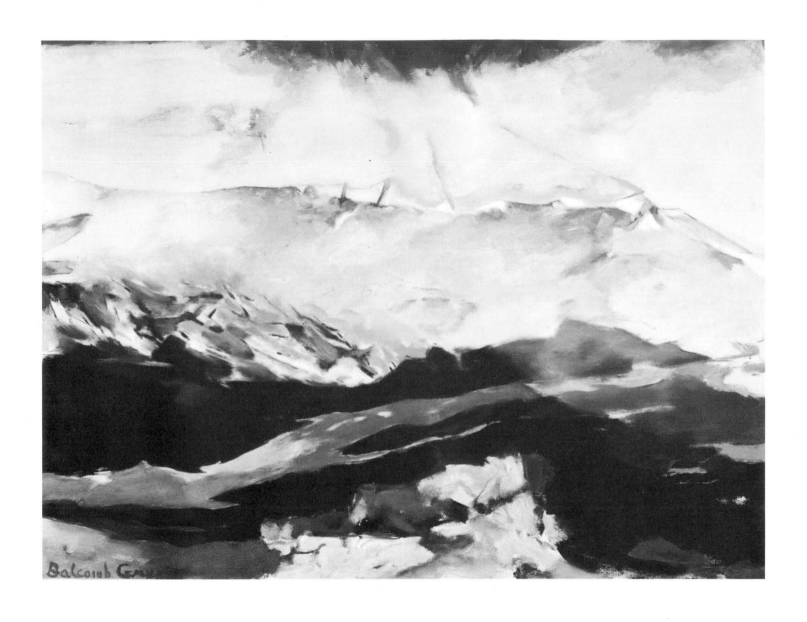

1958 Driftwood Cove

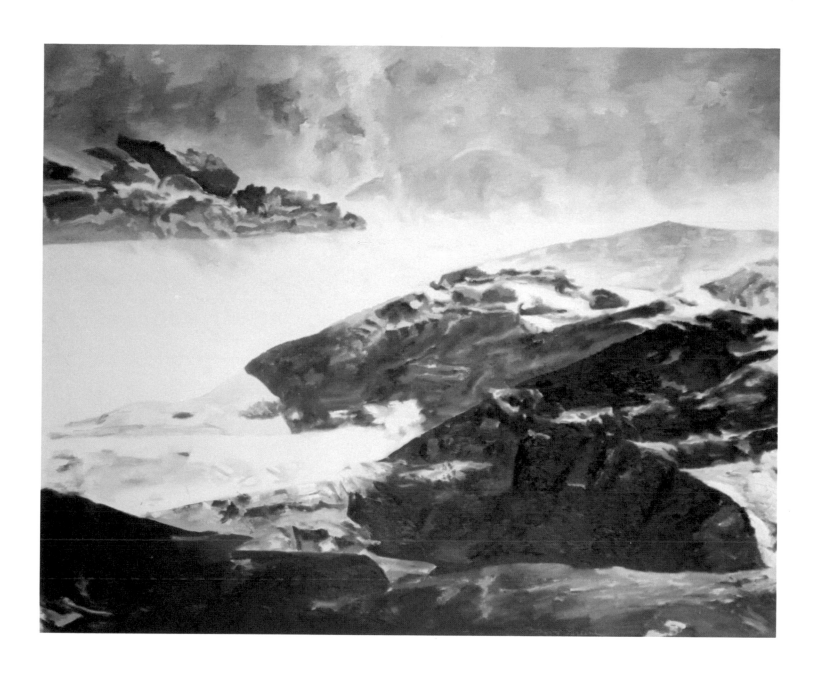

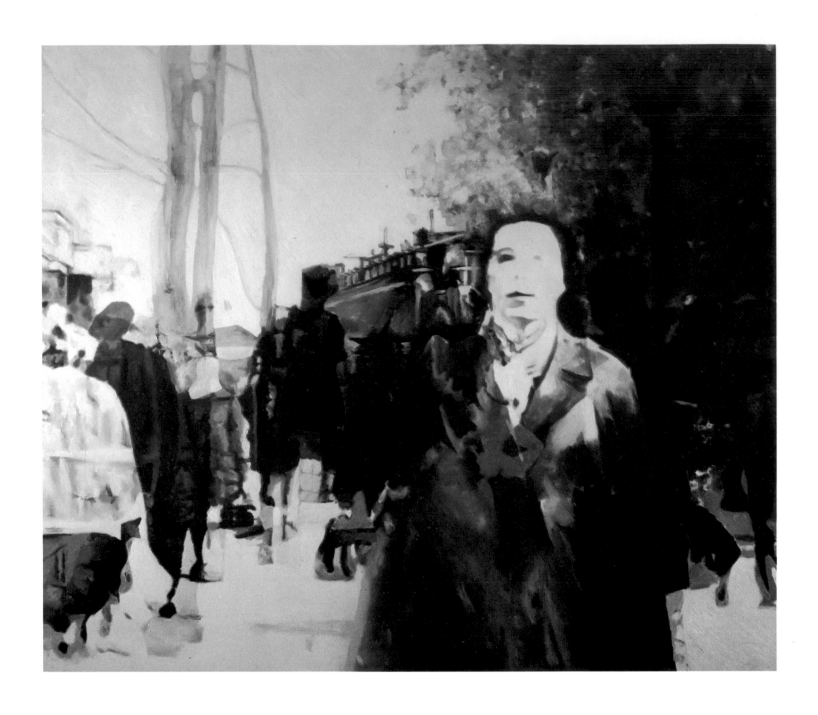

58 1967 Le Pont Neuf

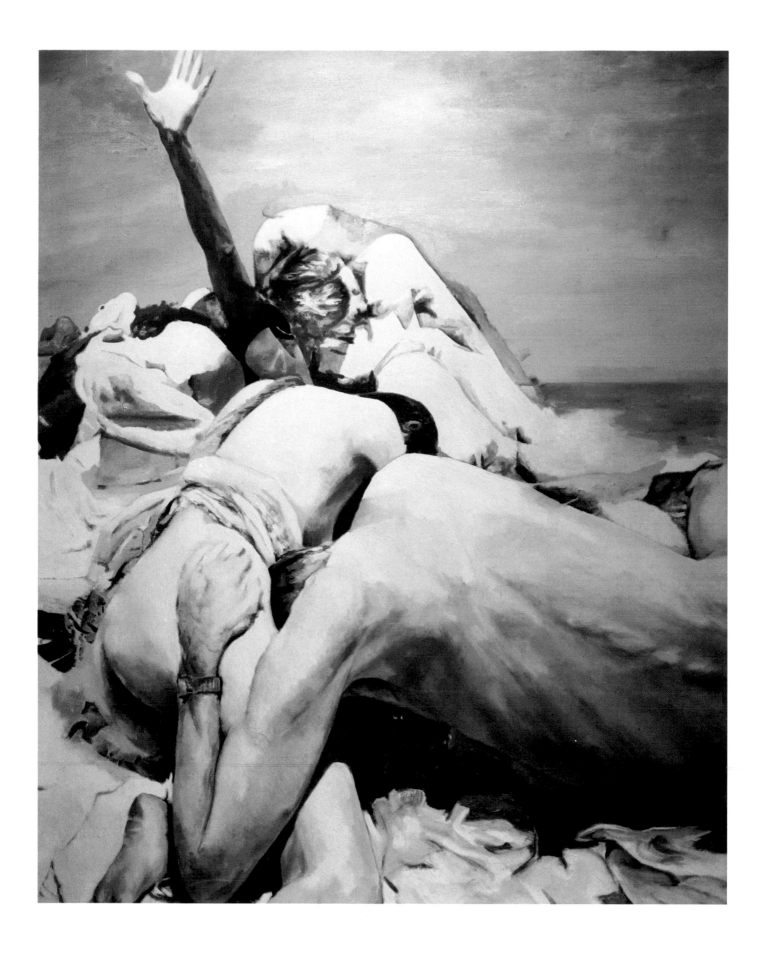

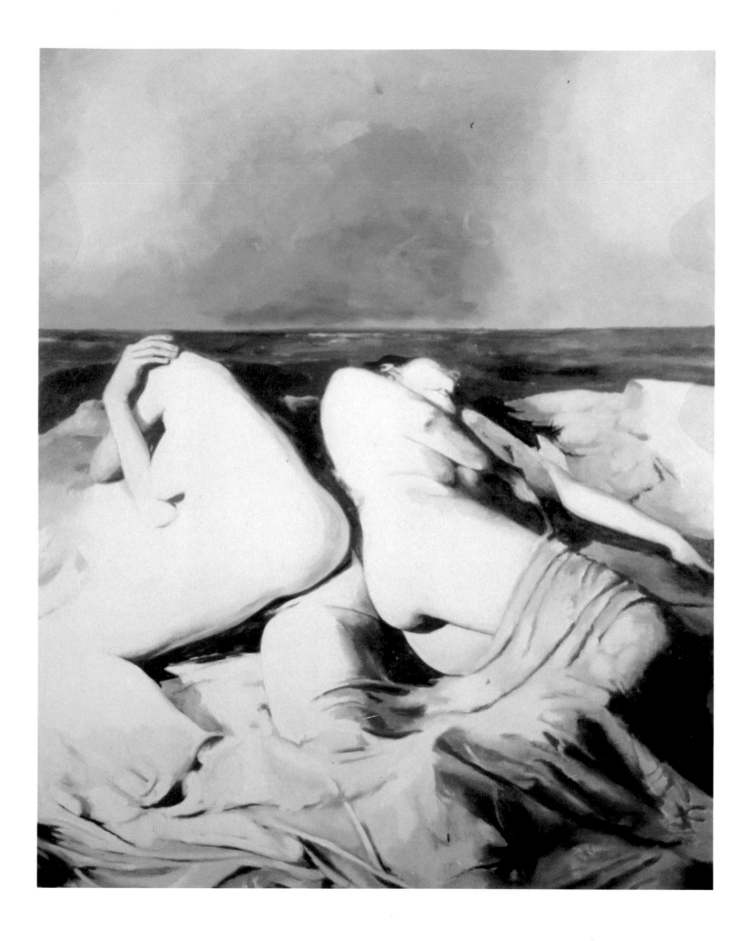

1970 Women by the Sea

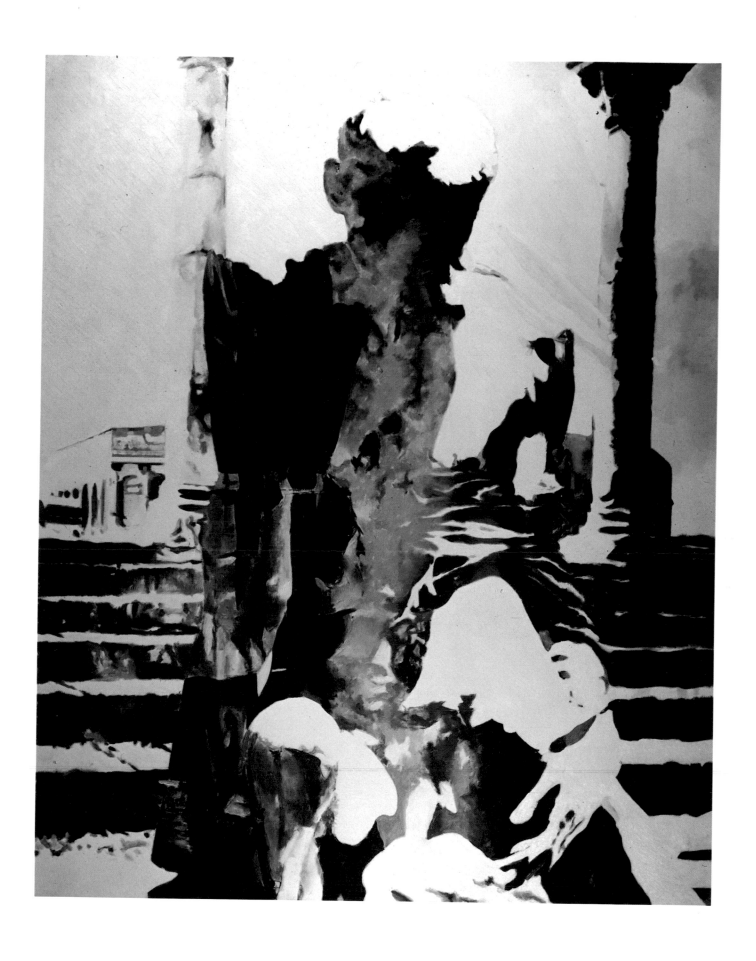

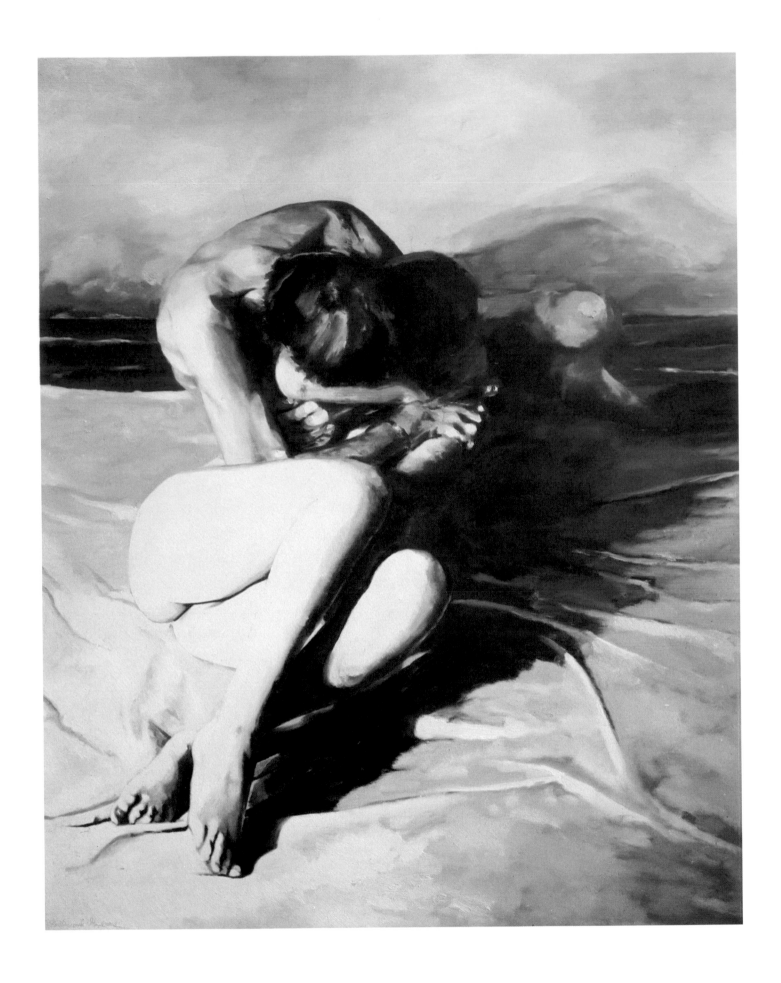

62 1971 Shadows on the Beach

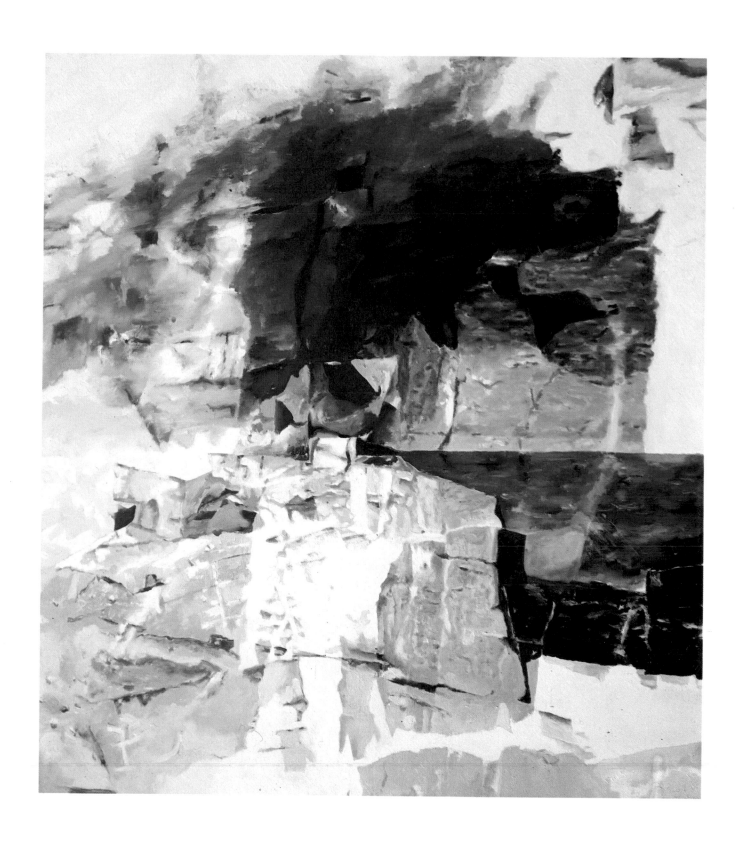

1973 Wind over the Sea *63*

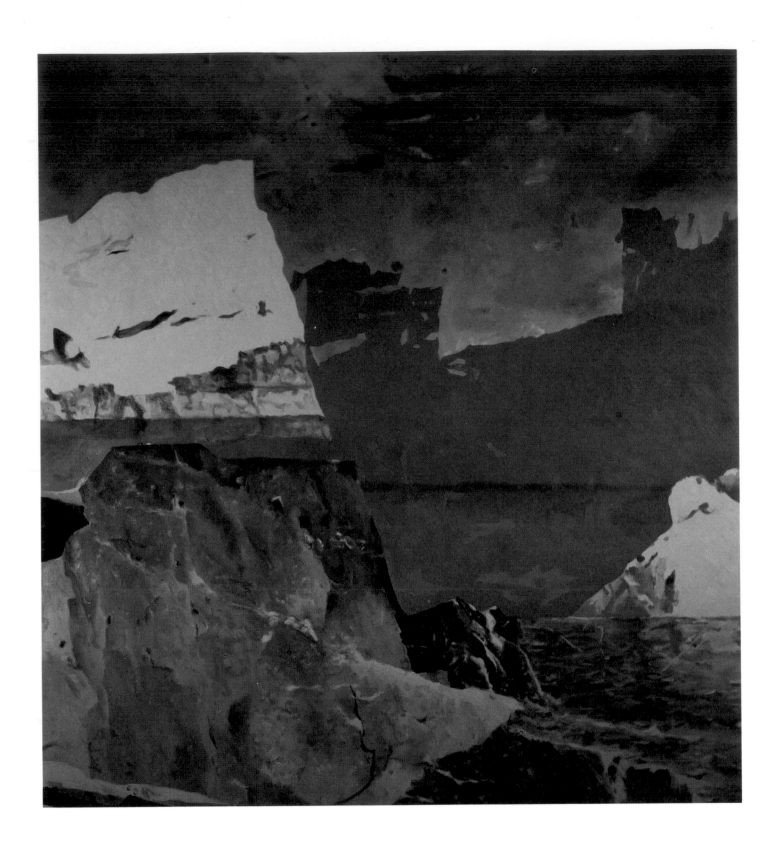

1974 Moonlight by the Sea

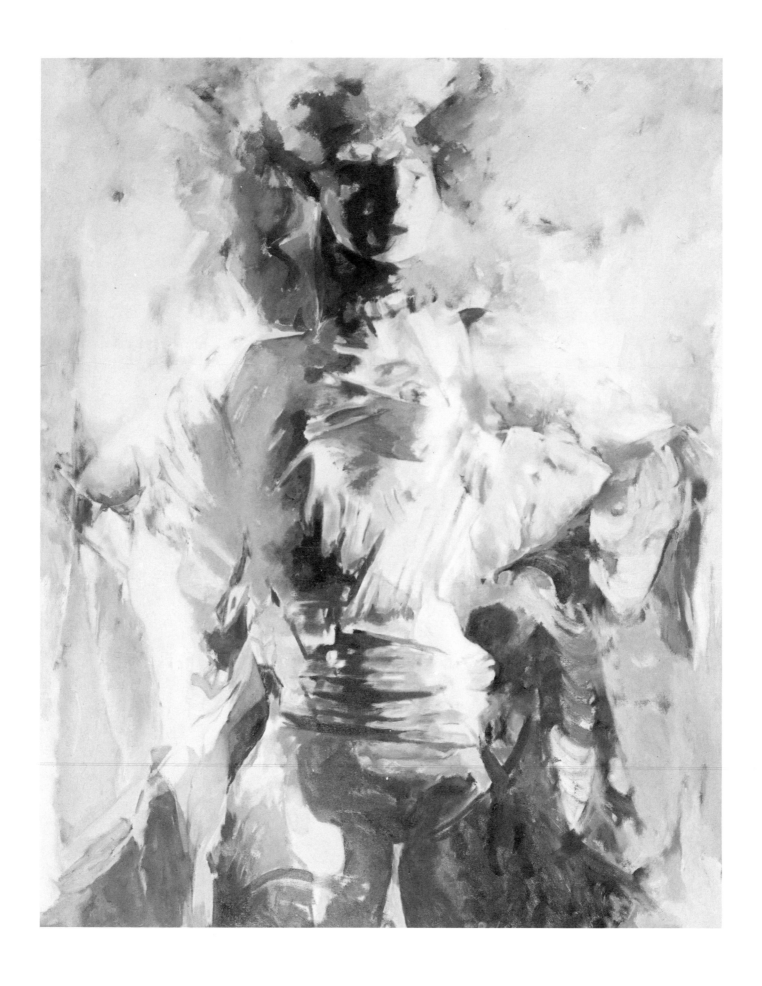

1959 Youth 65

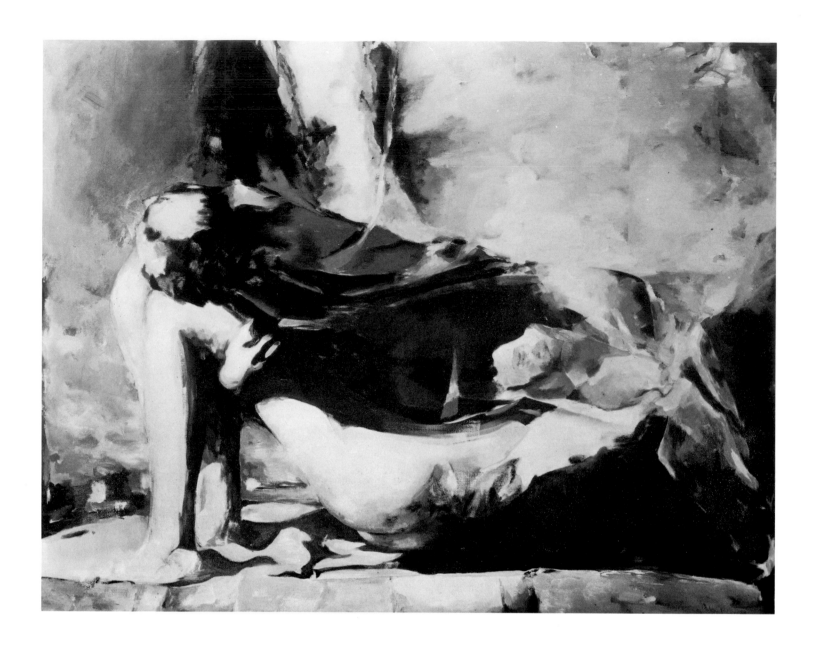

1960 Darkness and Light

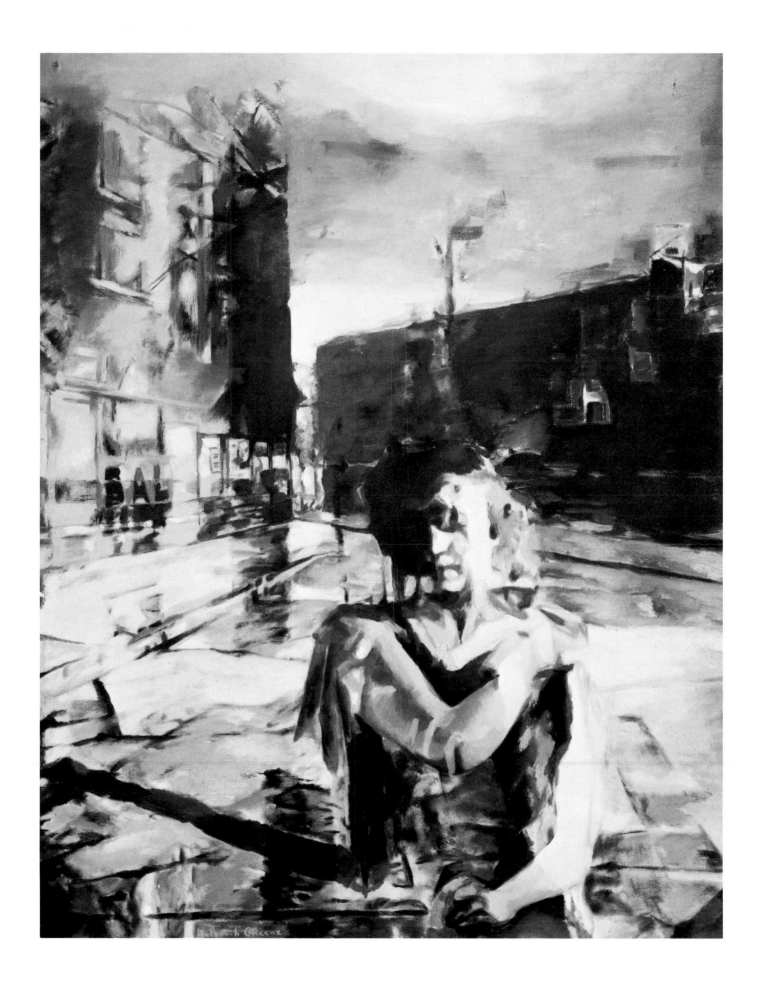

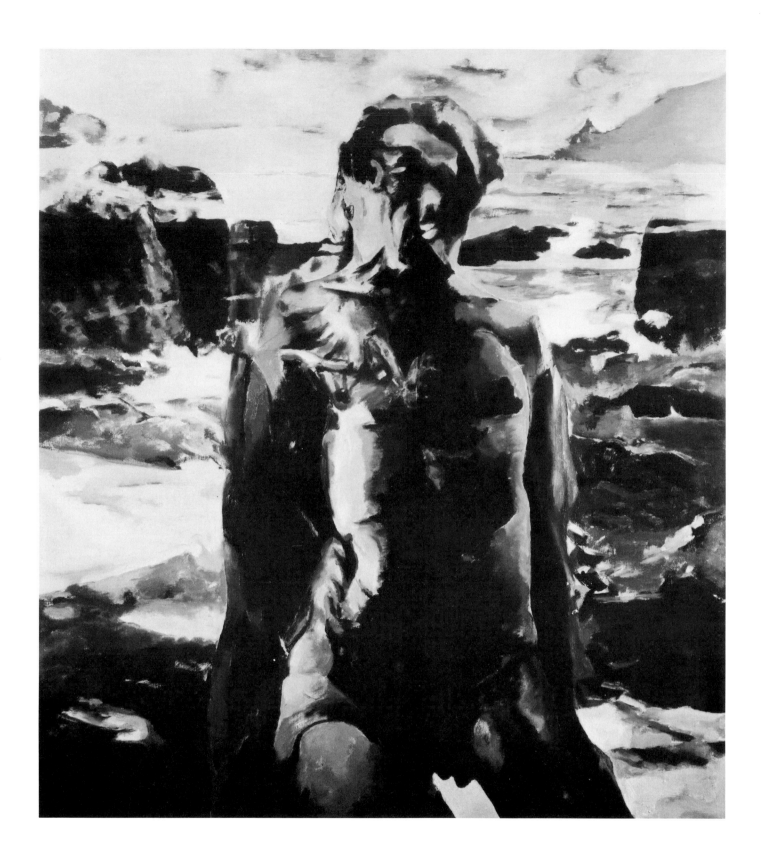

68 1961 Man

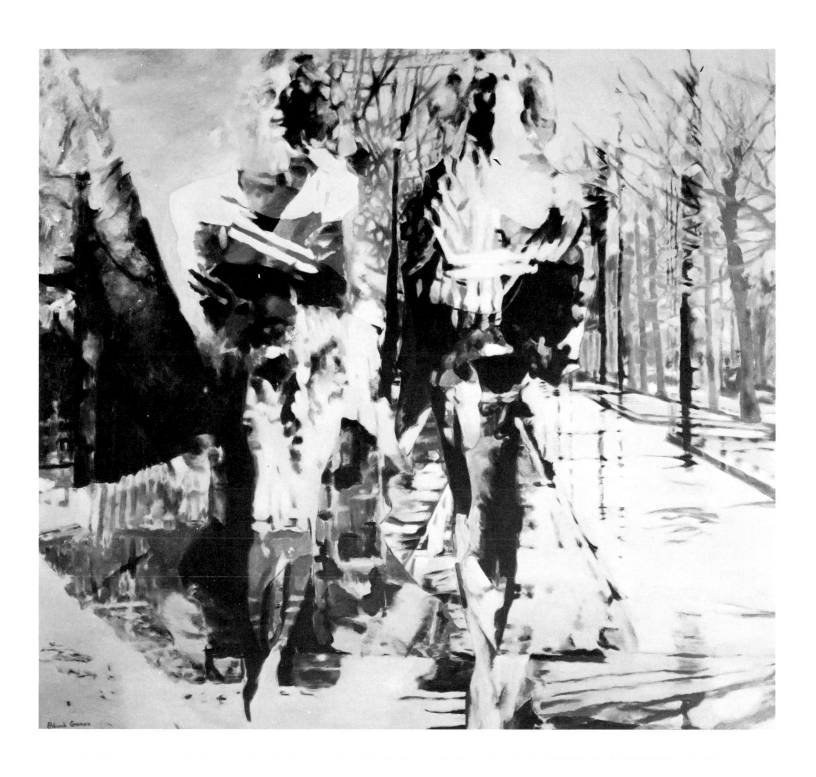

1961 The Boulevard—Paris *69*

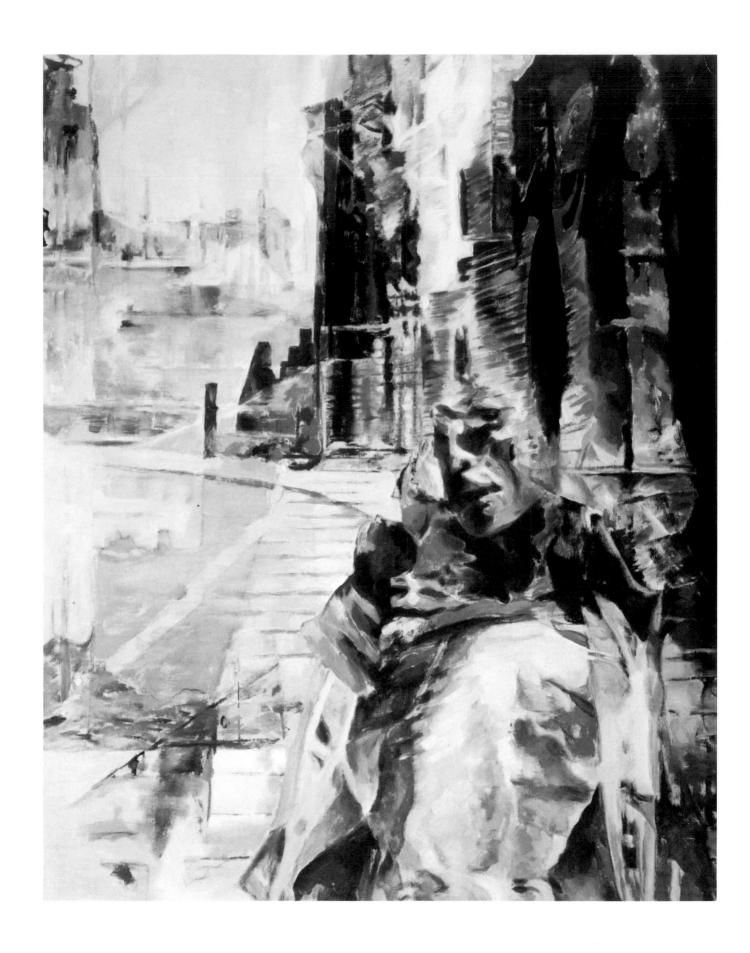

1961 The Cathedral—Paris

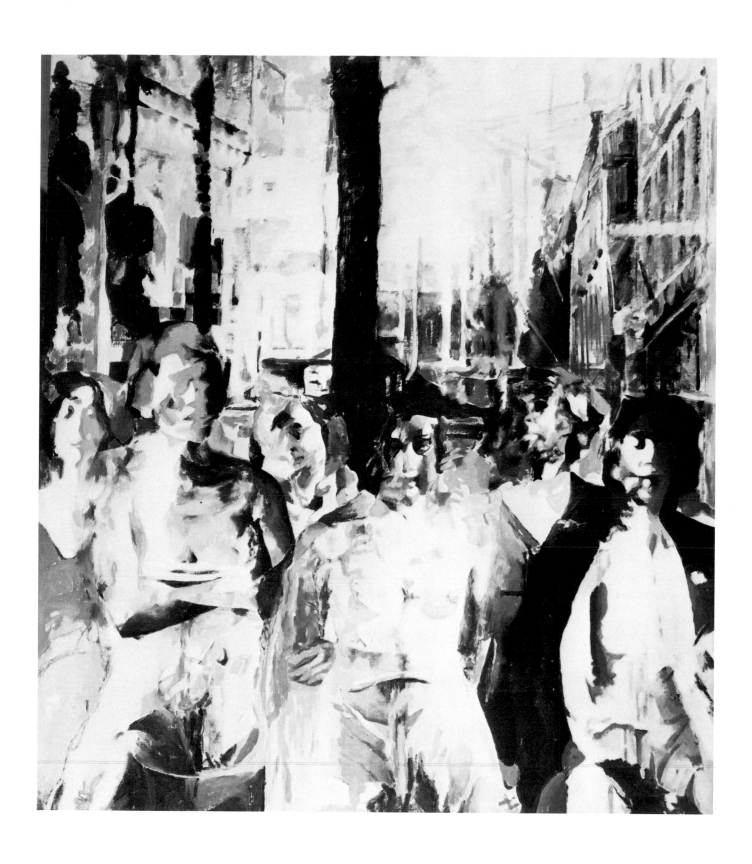

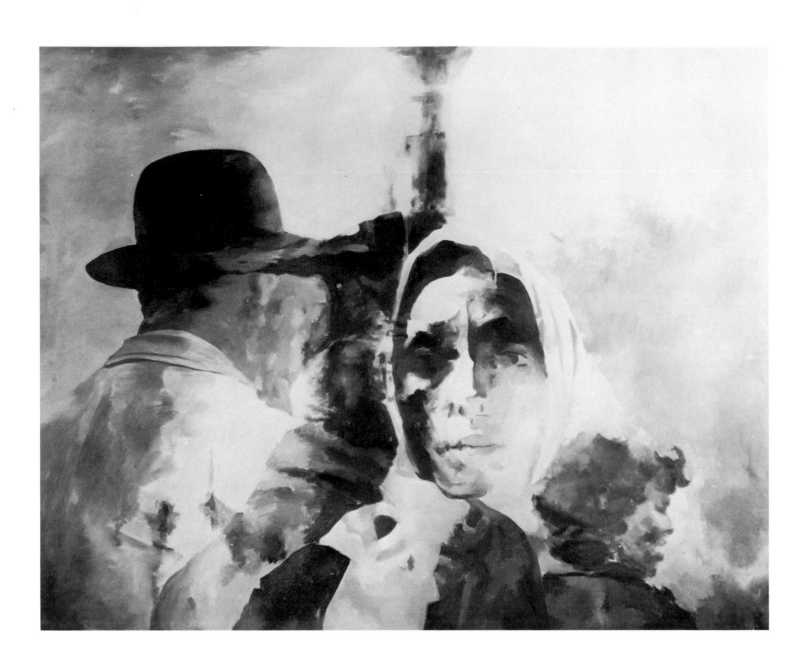

72 1961 Parade

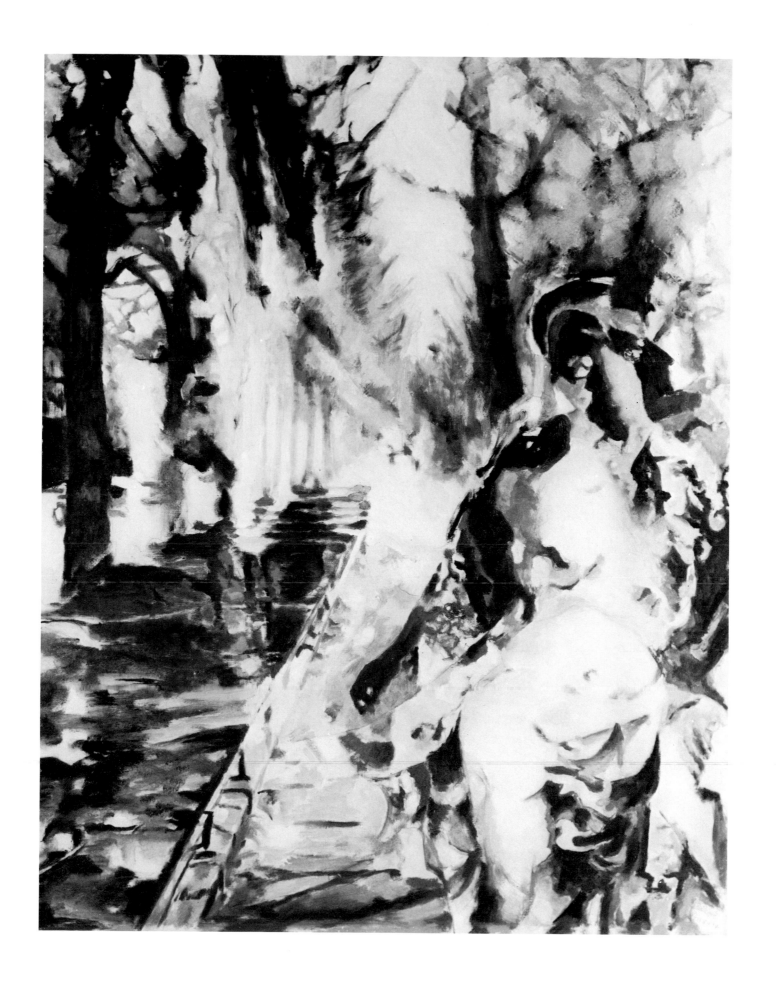

1962 Boulevard Haussmann 73

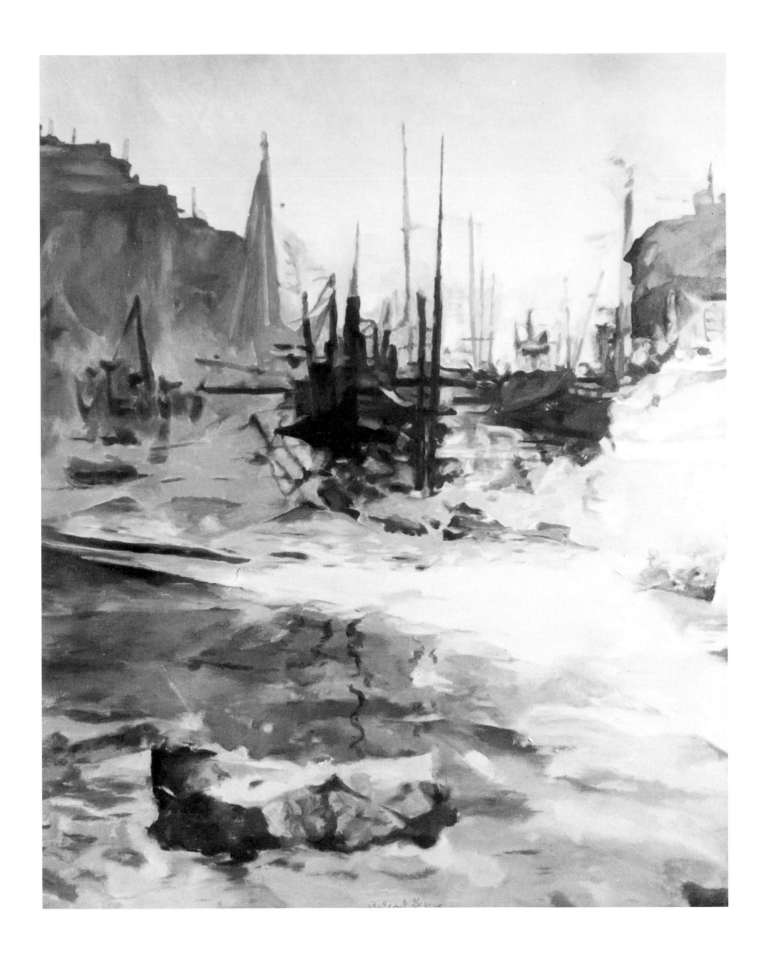

74 1963 Northern Harbor

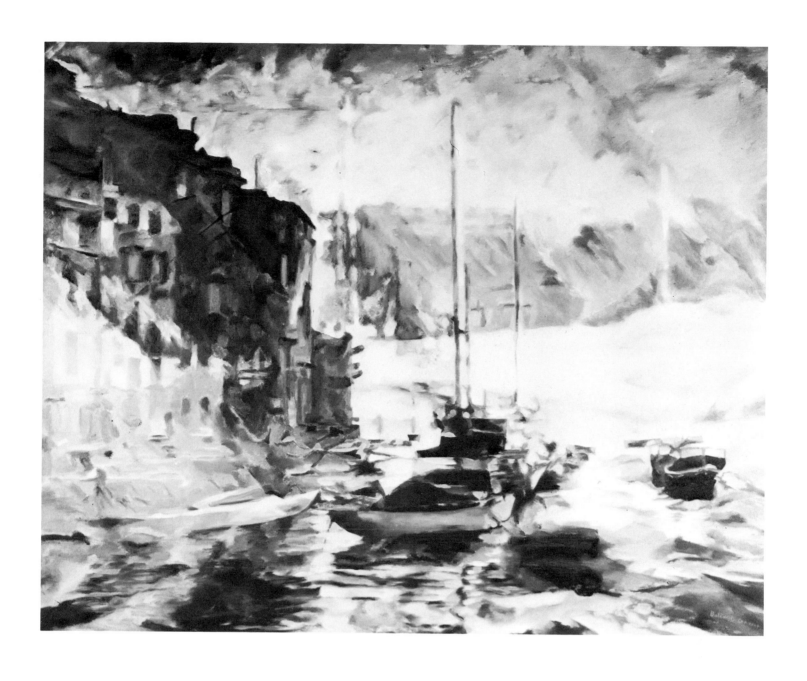

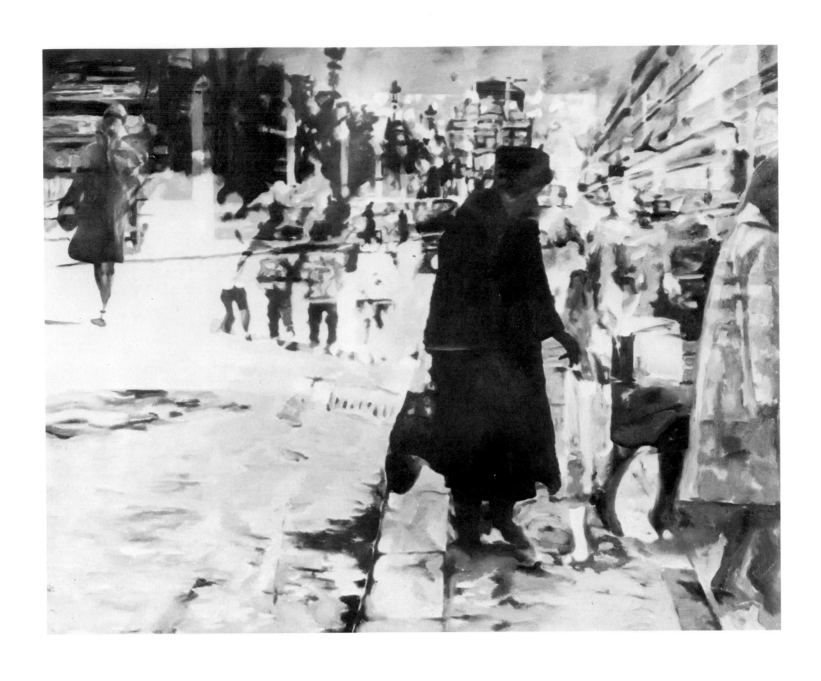

76 1963 The Avenue—The People

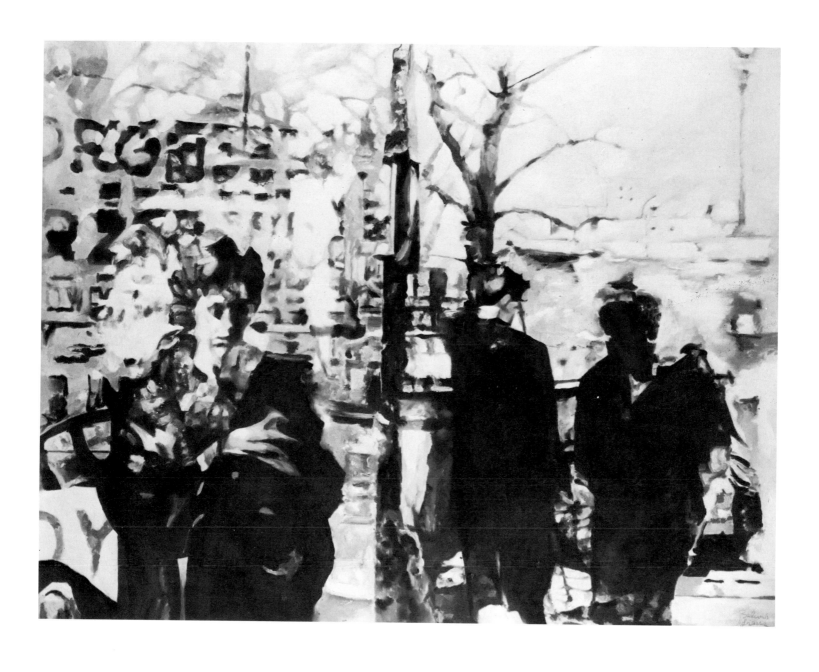

1964　Place du Châtelet　77

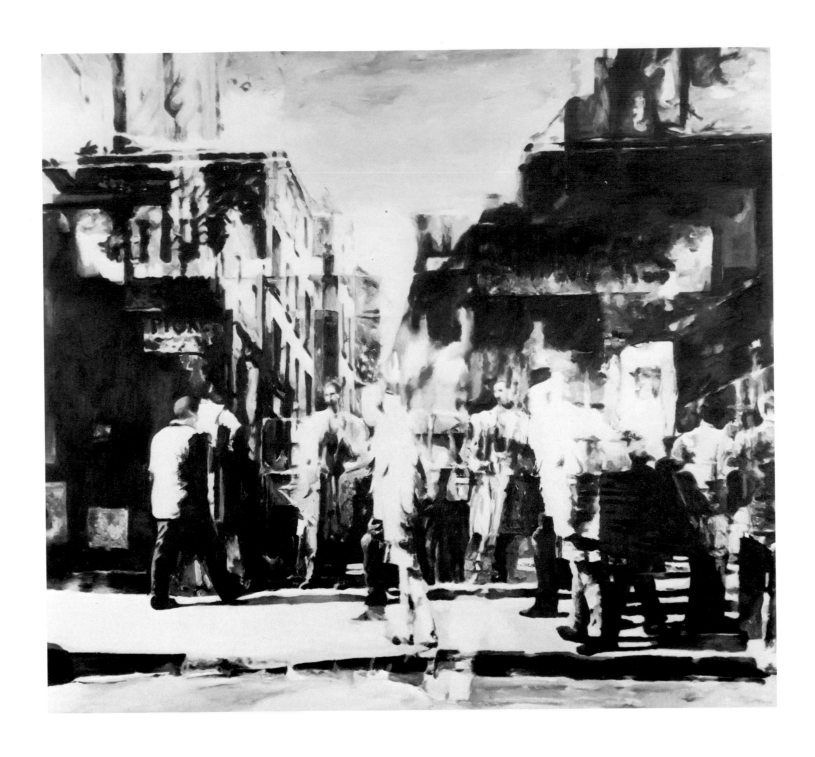

78 1964 Place Pigalle

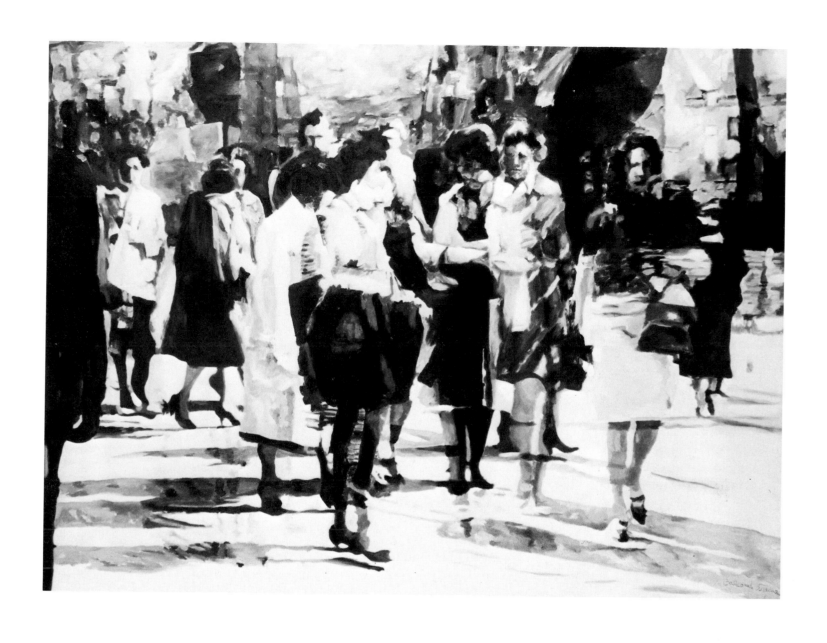

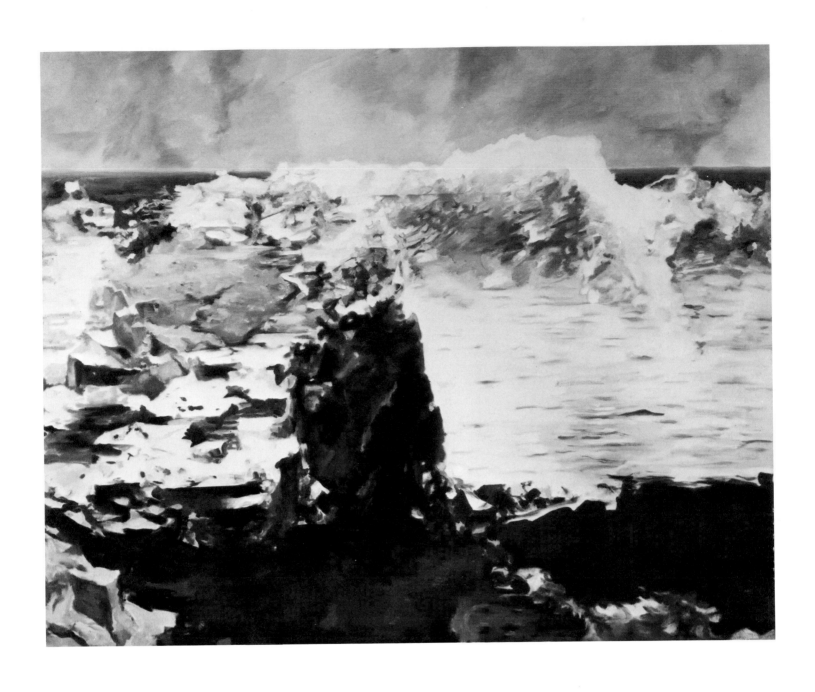

80 1964 The Enormous Wave

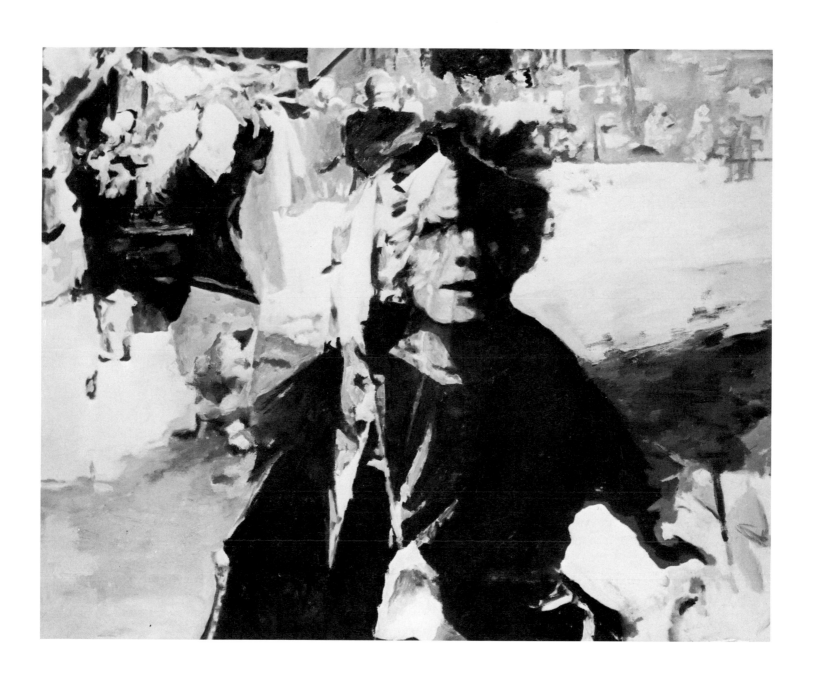

1964 Bois de Vincennes *81*

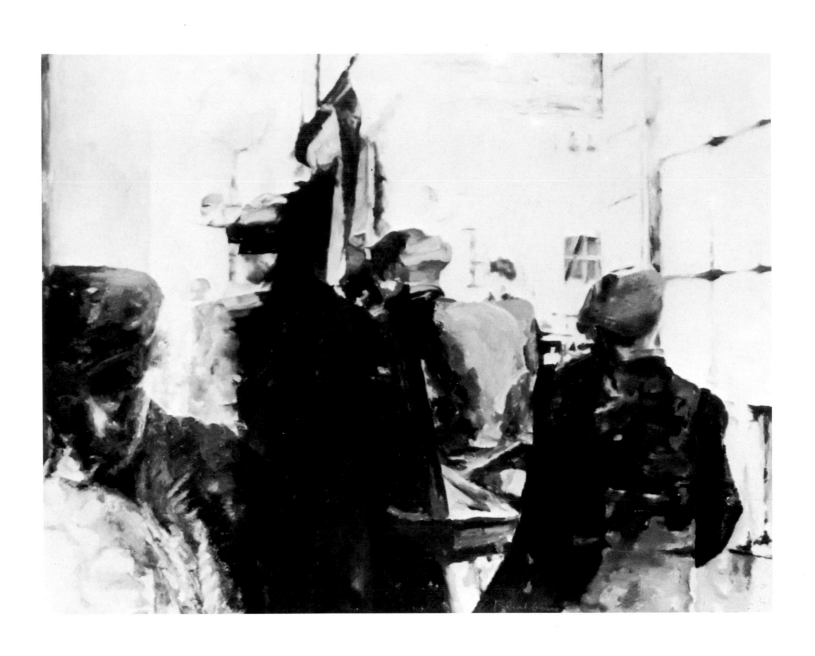

82 1965 Boulevard St. Michel

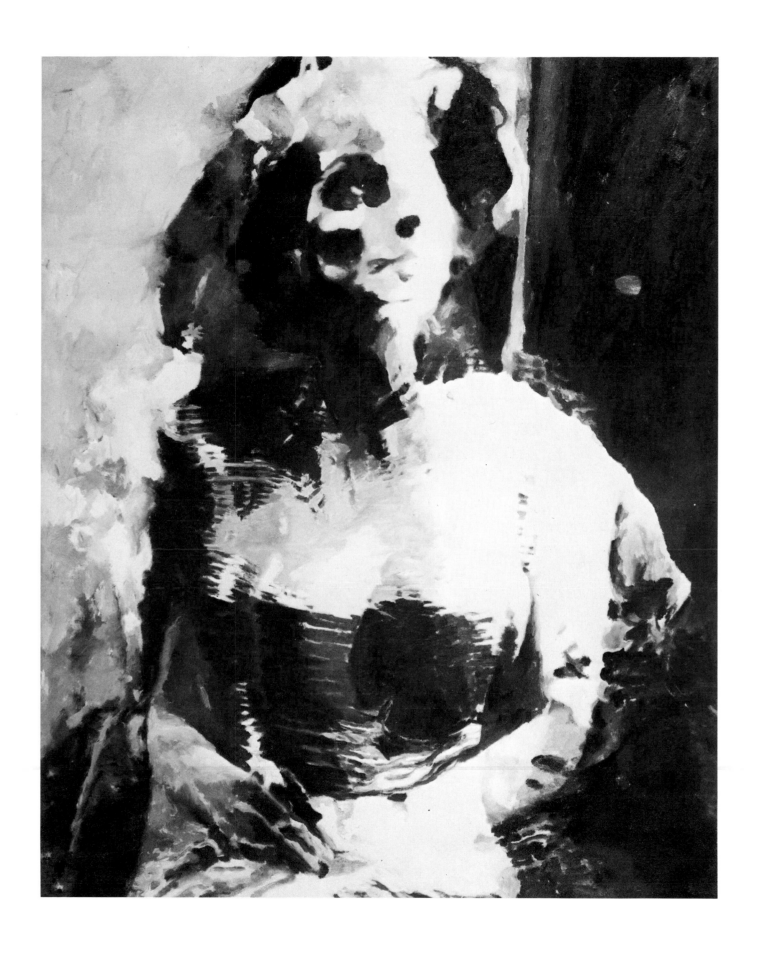

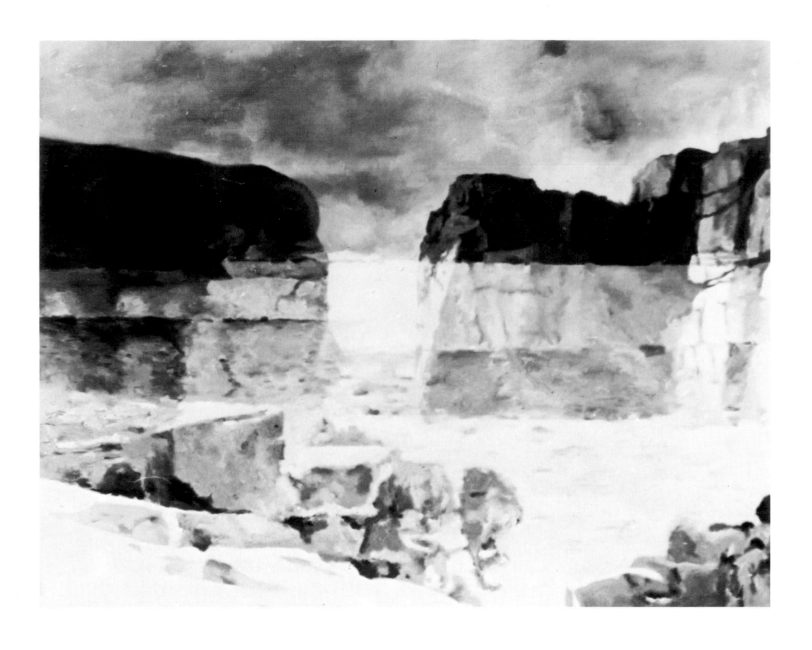

84 1965 Maine

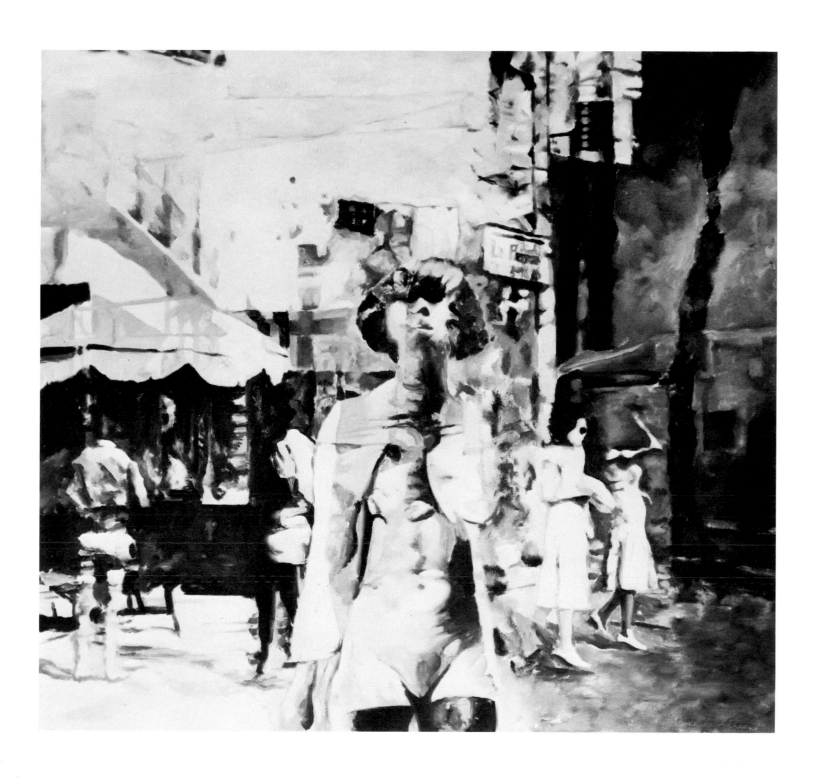

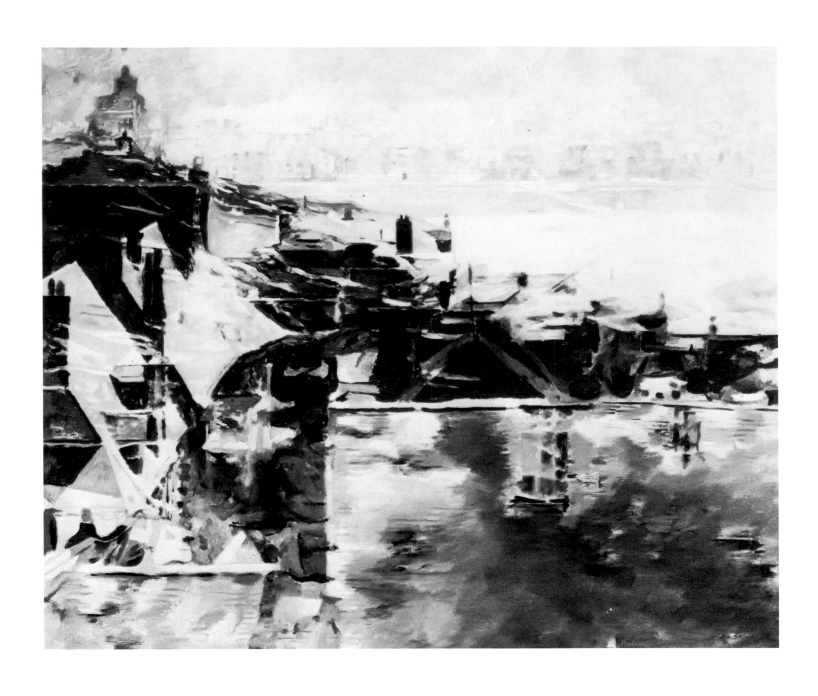

86 1966 Northern City

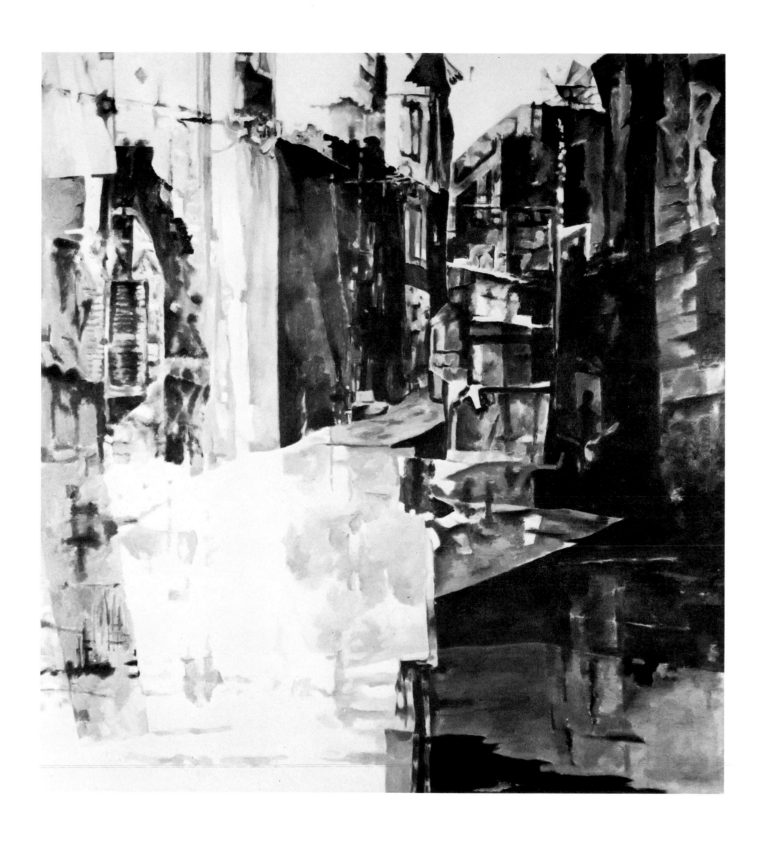

1966 Hill Town 87

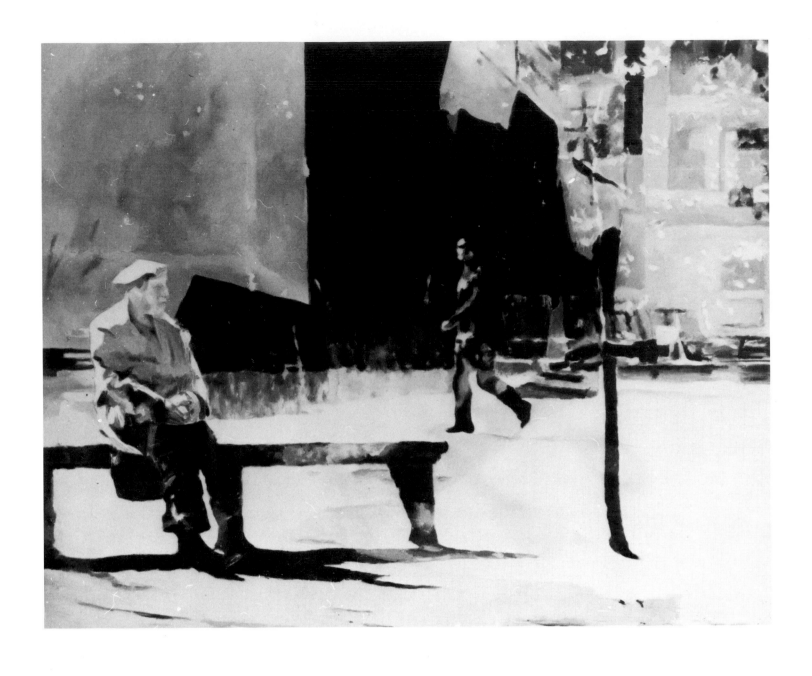

88 1966 Two Figures

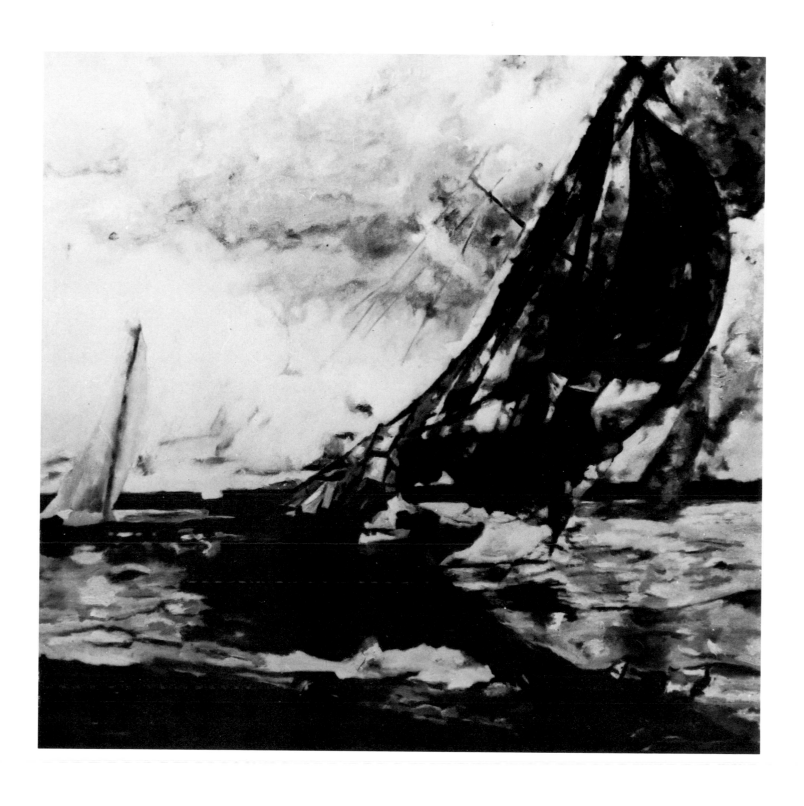

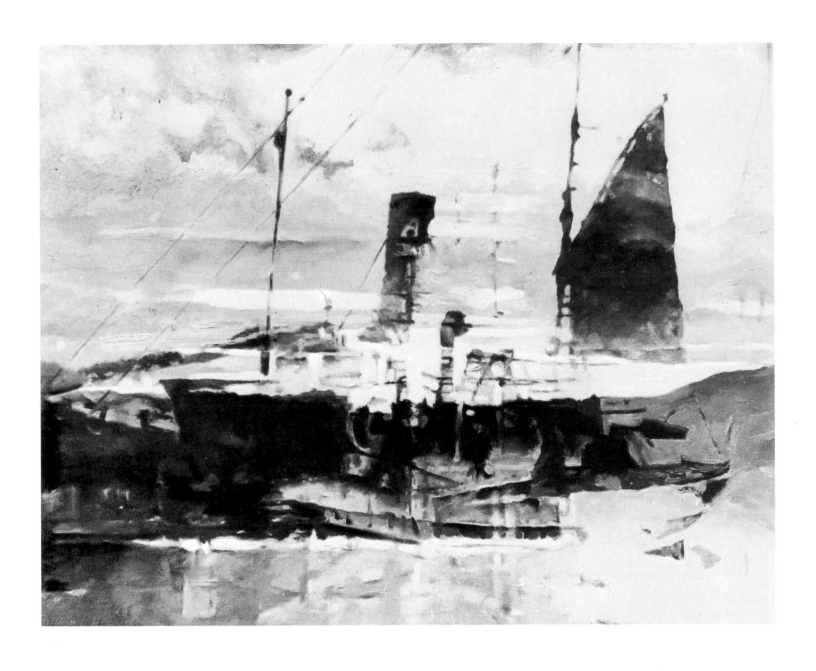

1968 The North Sea

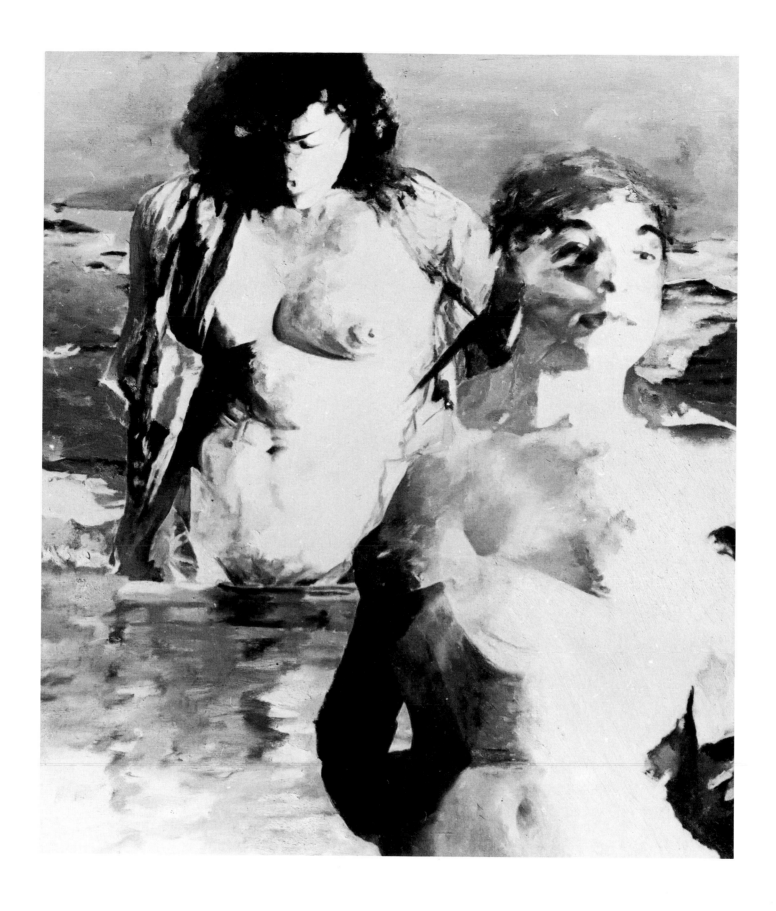

1968 Bathers 91

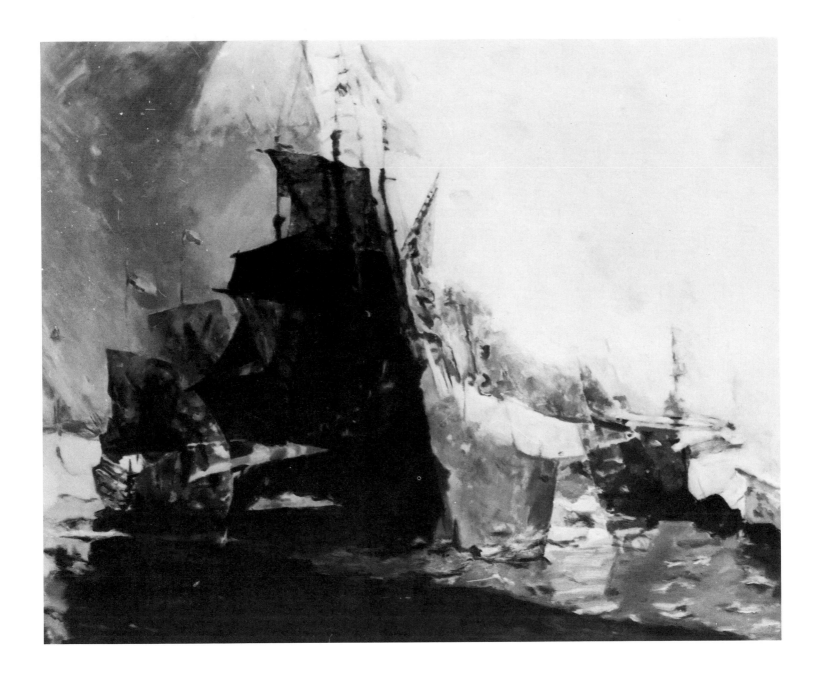

92 1969 Armada

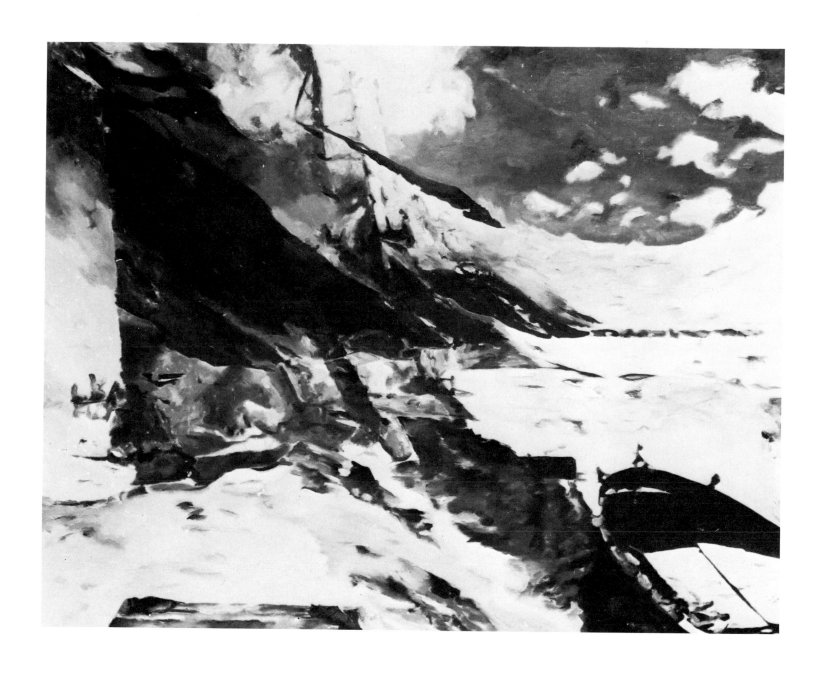

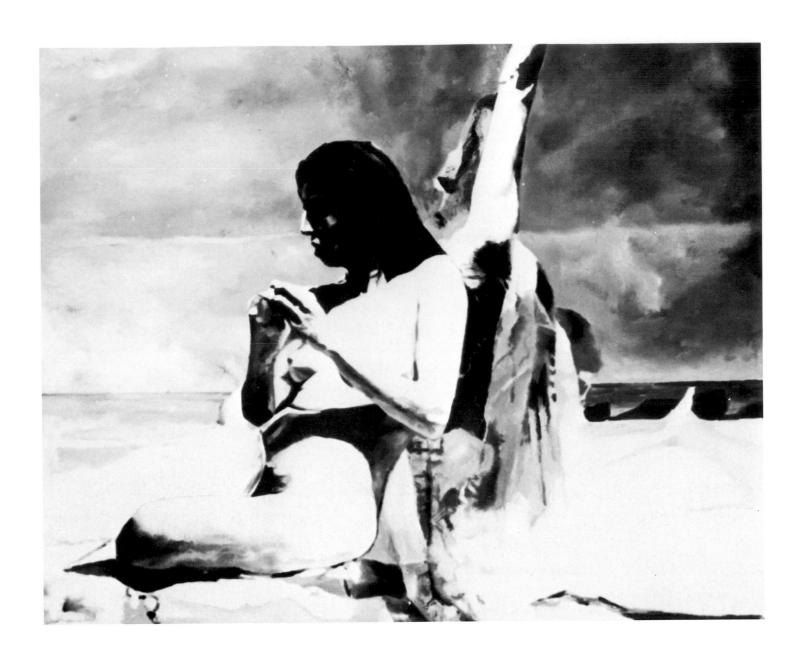

94 1969 Beside the Sea

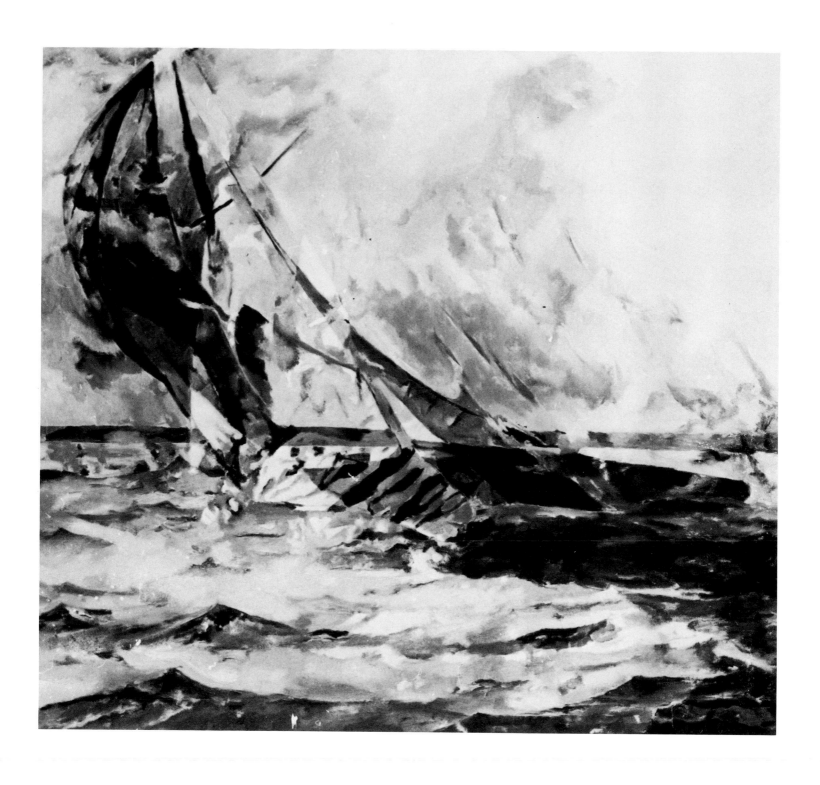

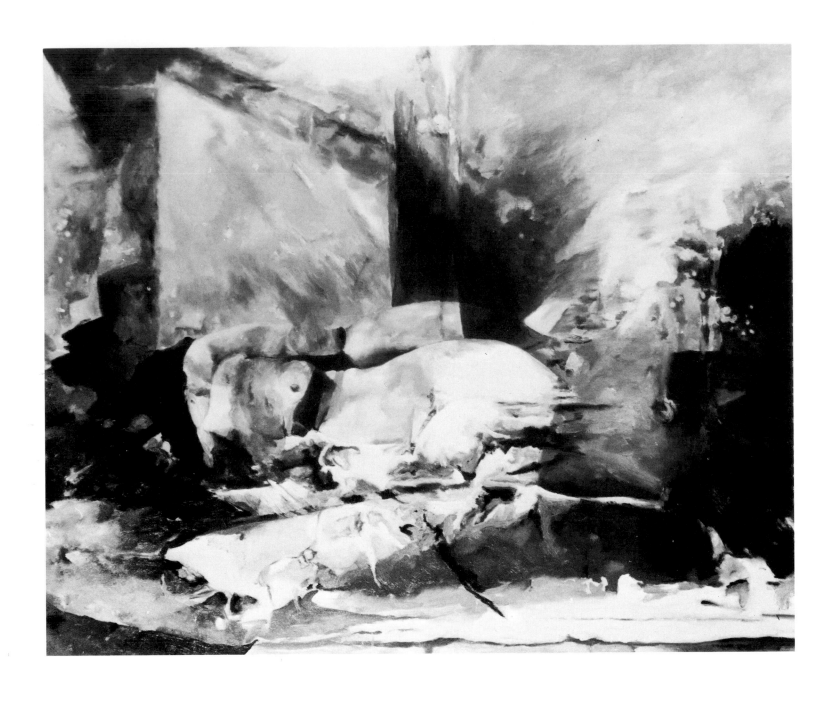

96 1969 Looking-Glass Woman

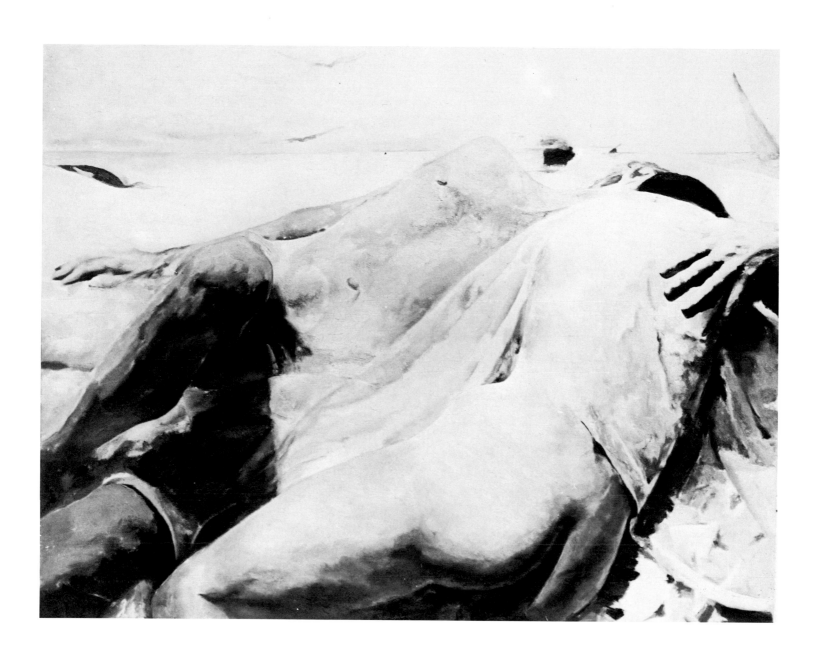

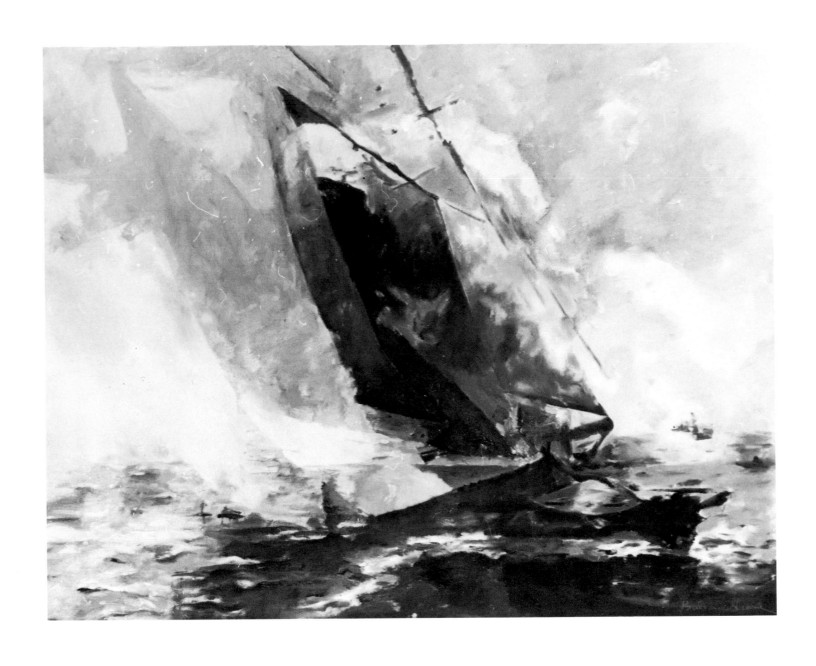

98 1969 Wind and Sails

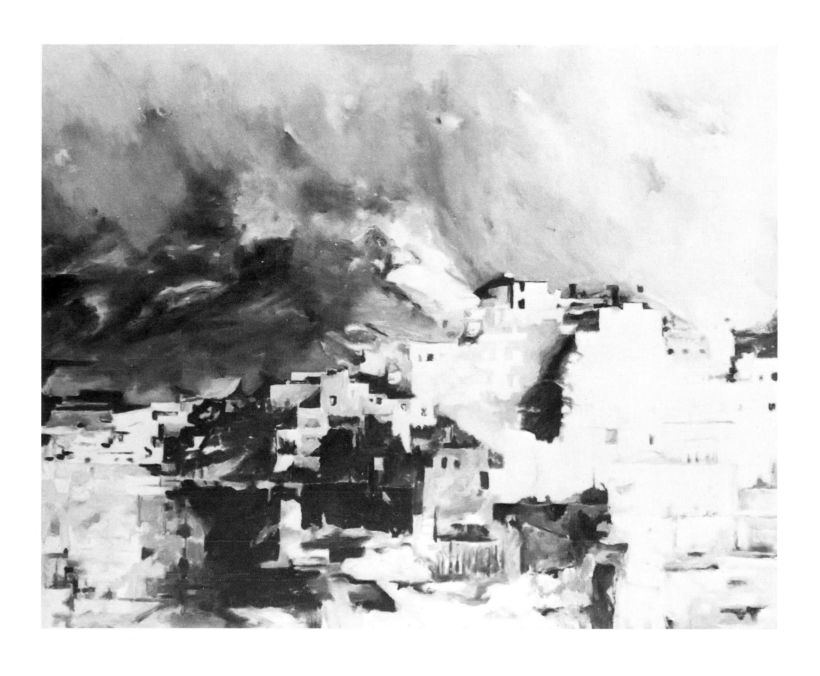

1969 View of Tangier 99

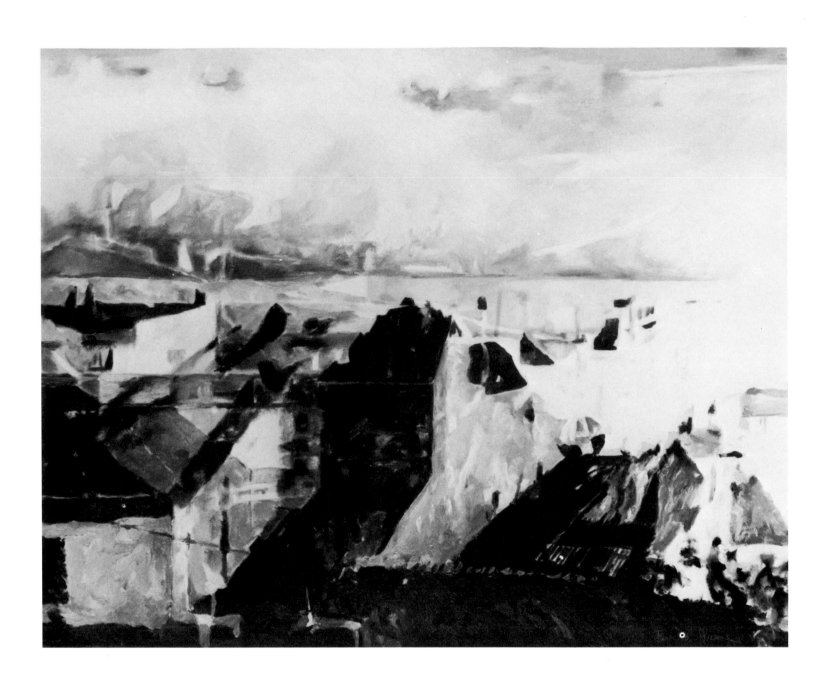

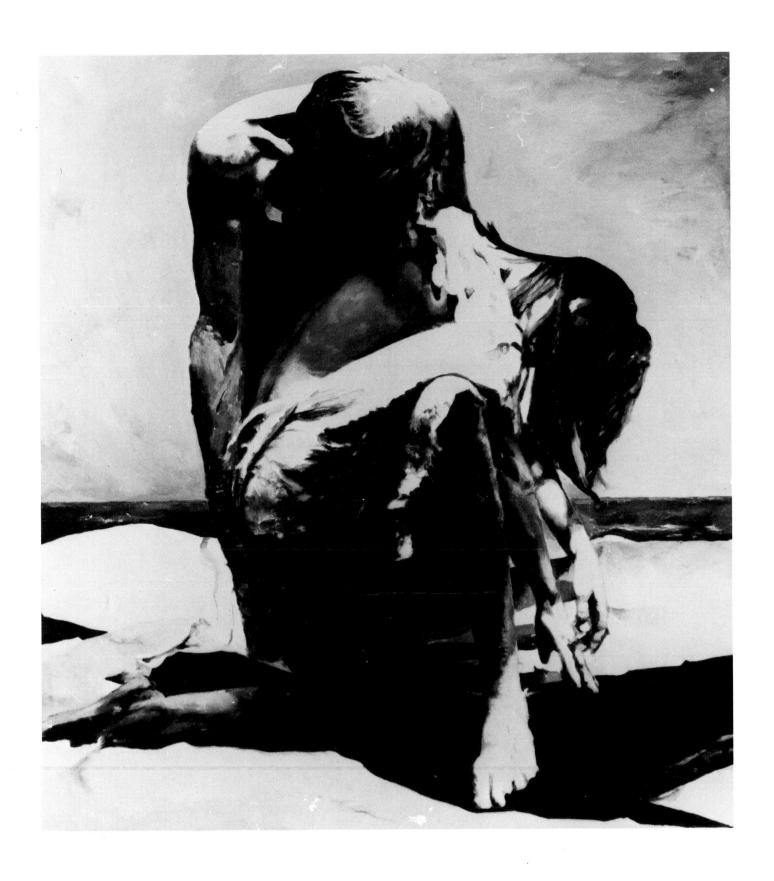

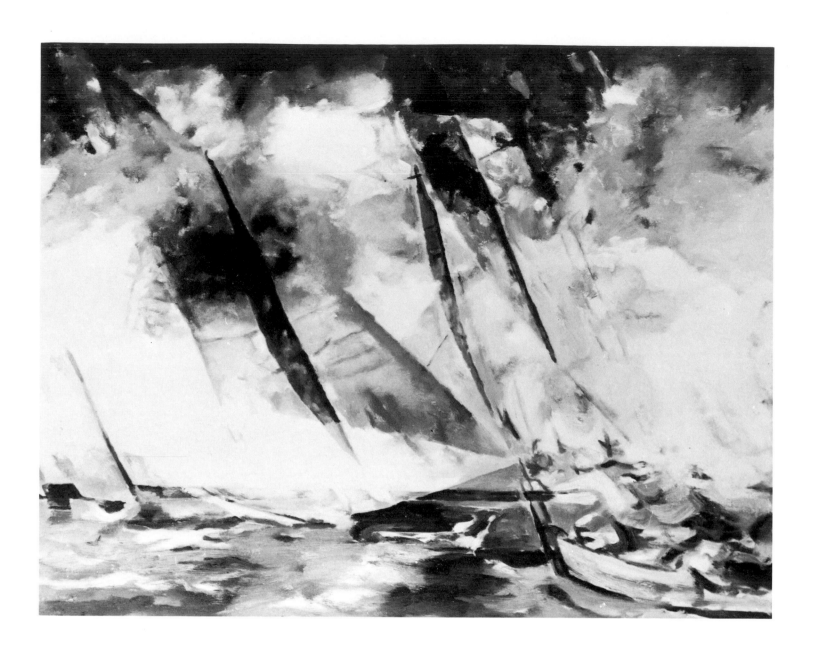

102 1970 Storm Clouds

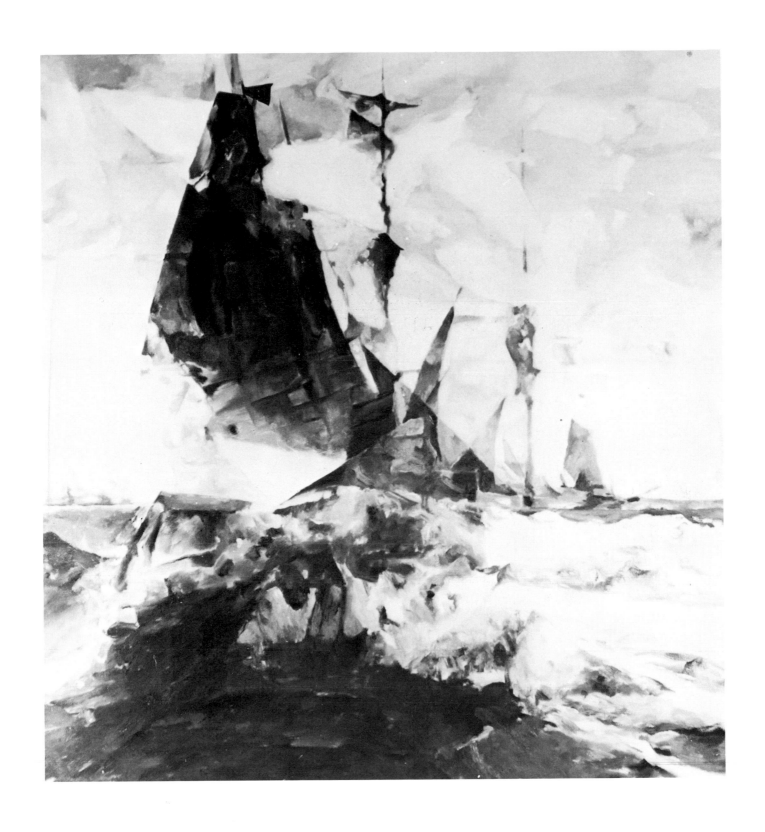

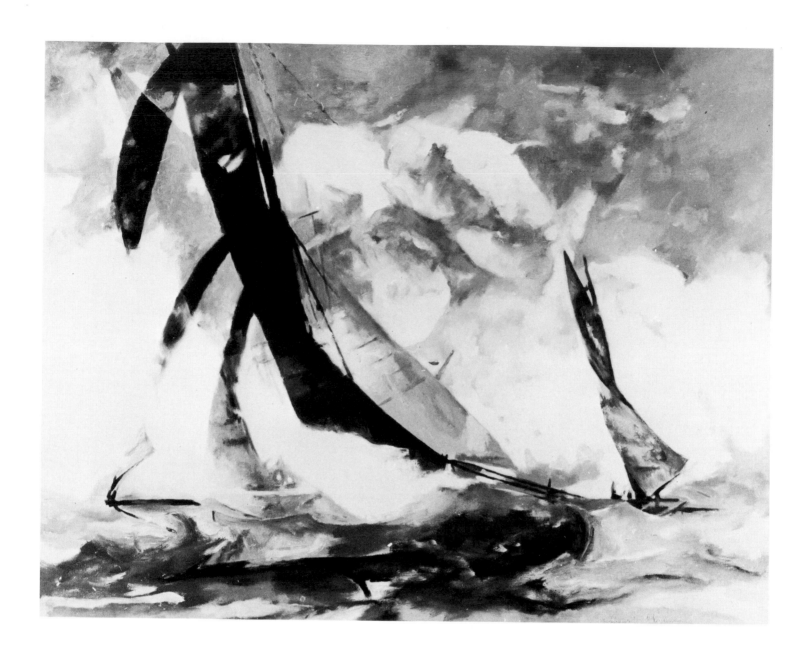

104 1971 Wind in October

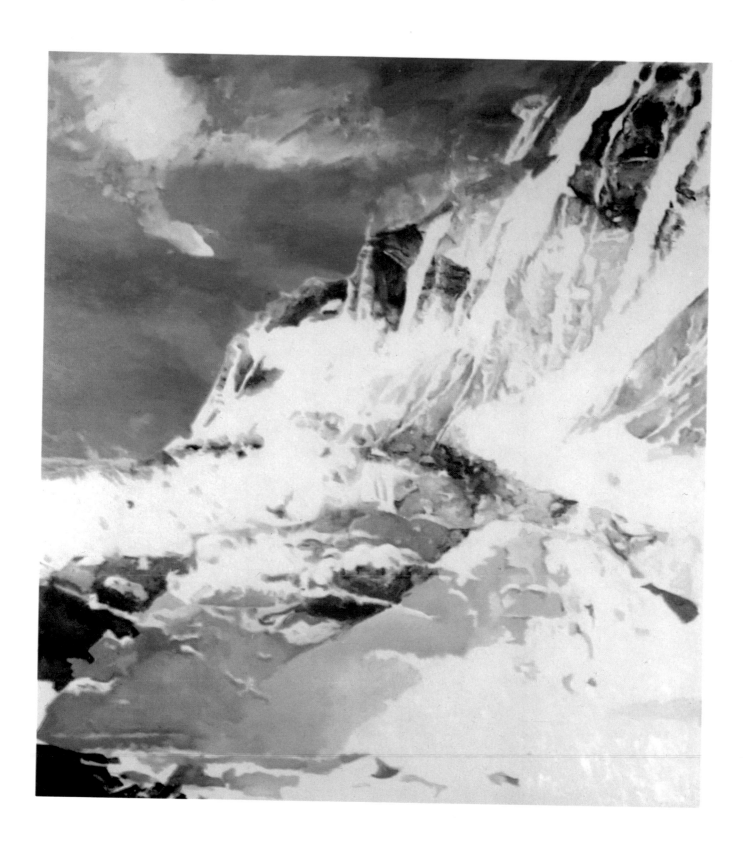

1974 Lightning and Storm 105

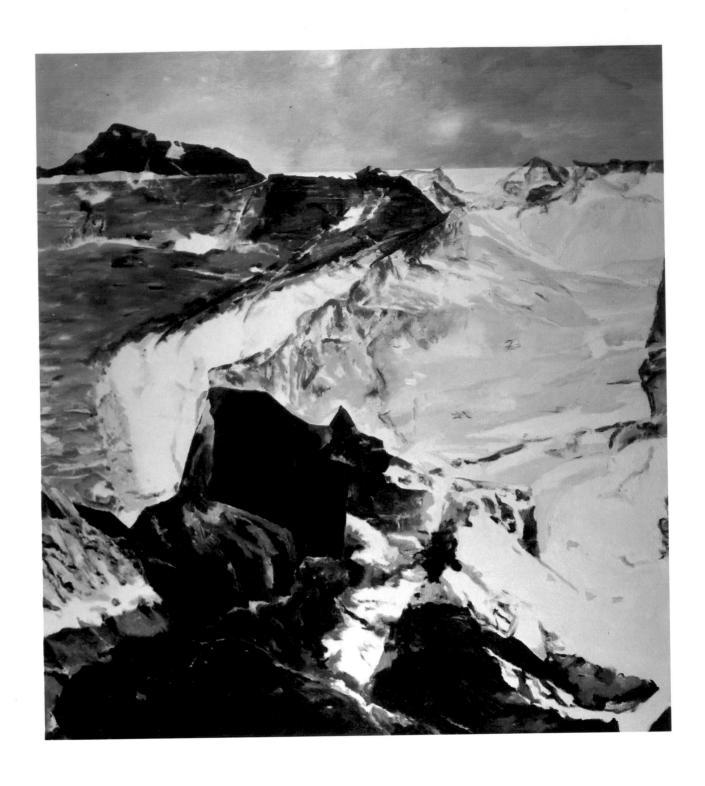

1975 Meeting of Land and Sea

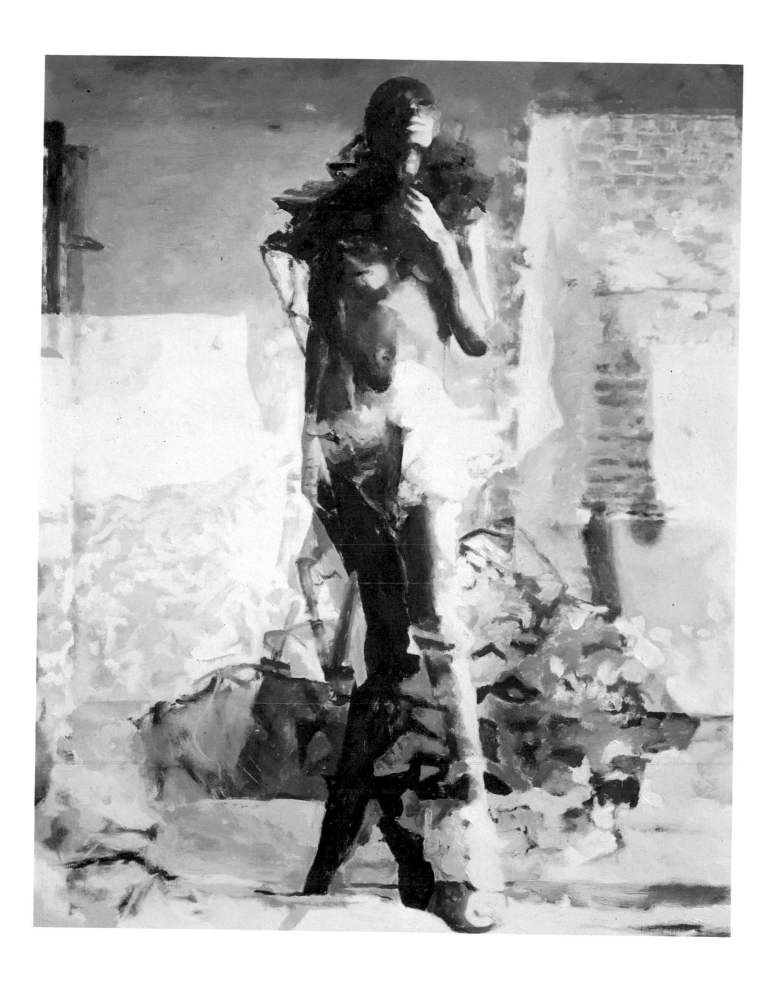

1975 Night on the Edge of Town

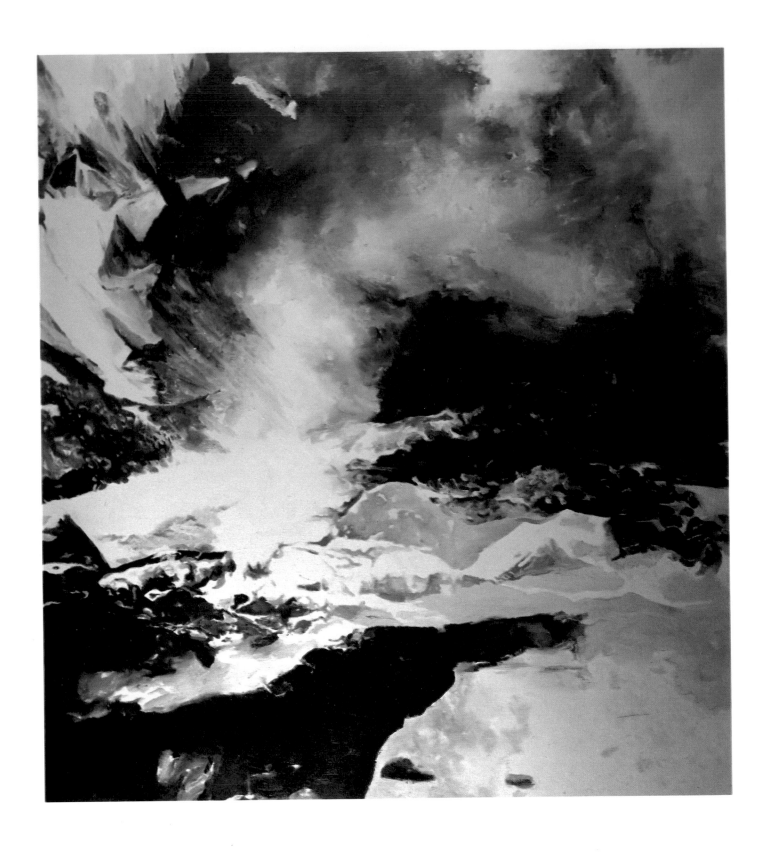

1976 The Great Wind Over Land and Sea

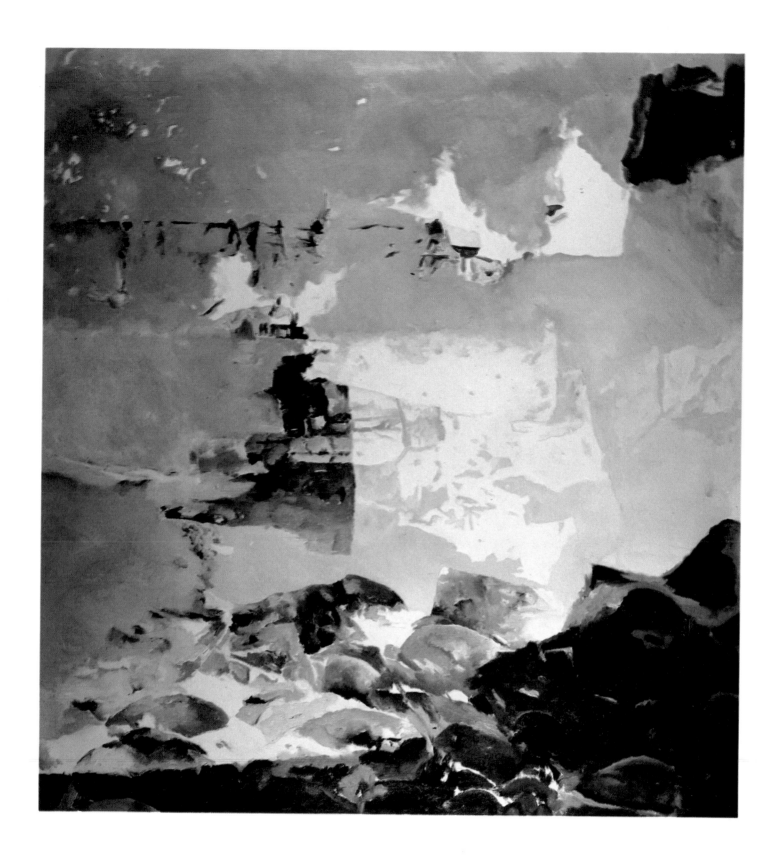

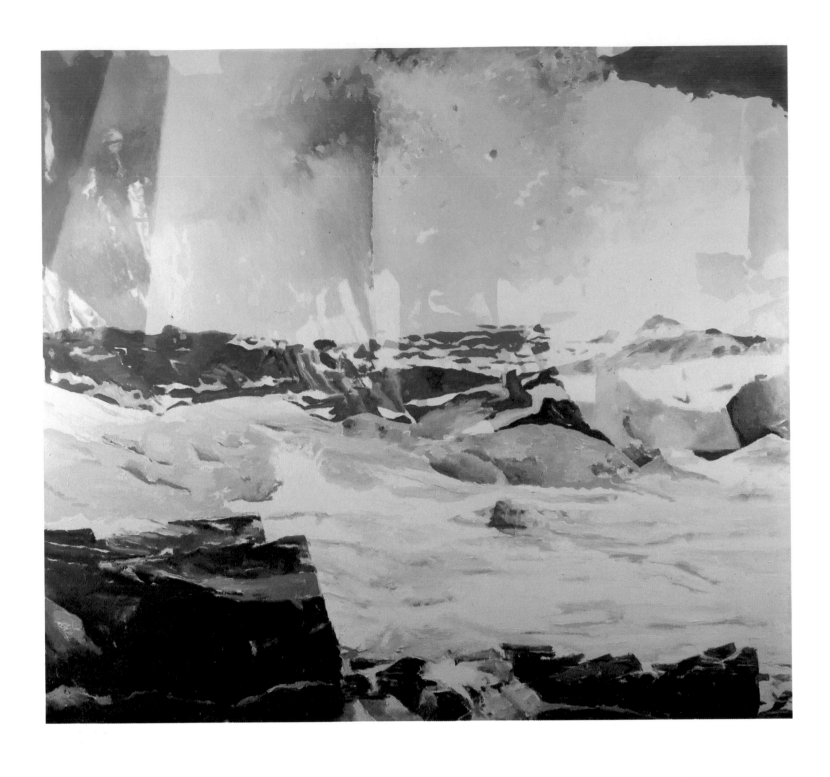

110 1976 Sails on Dark Water

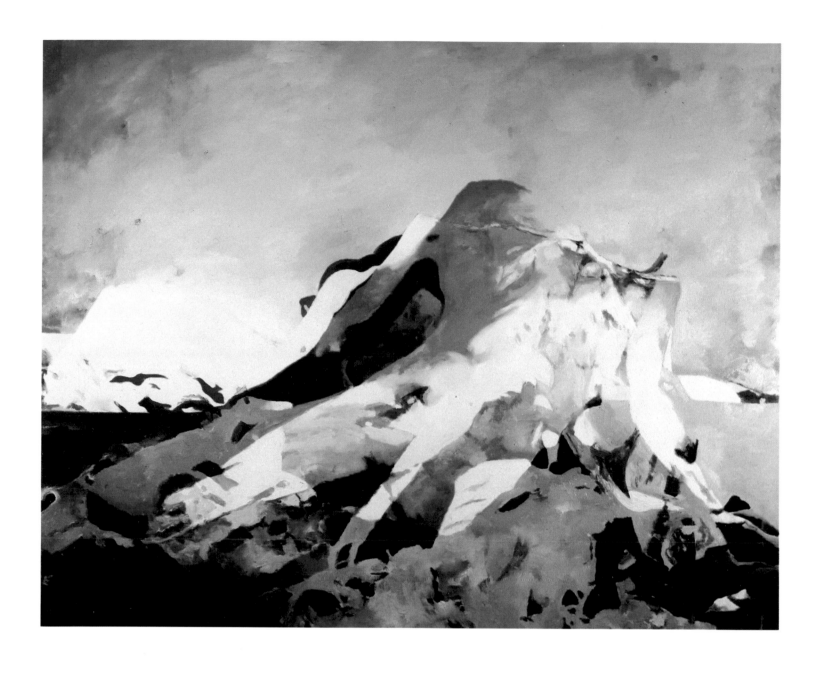

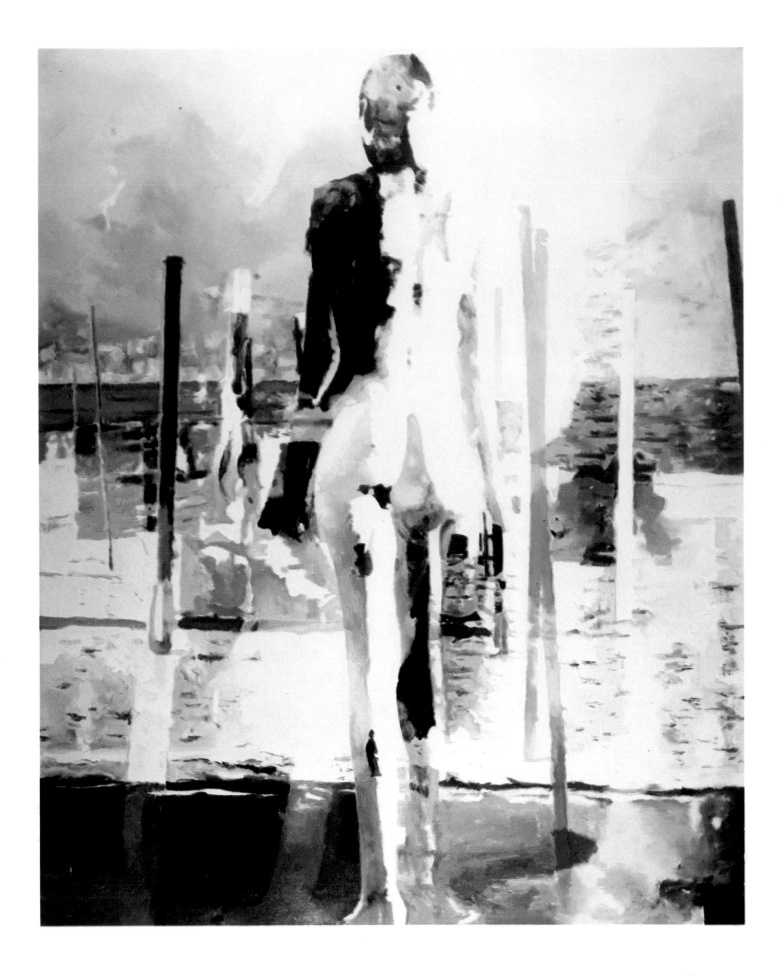

112 1976 The Beach Near St. Tropez

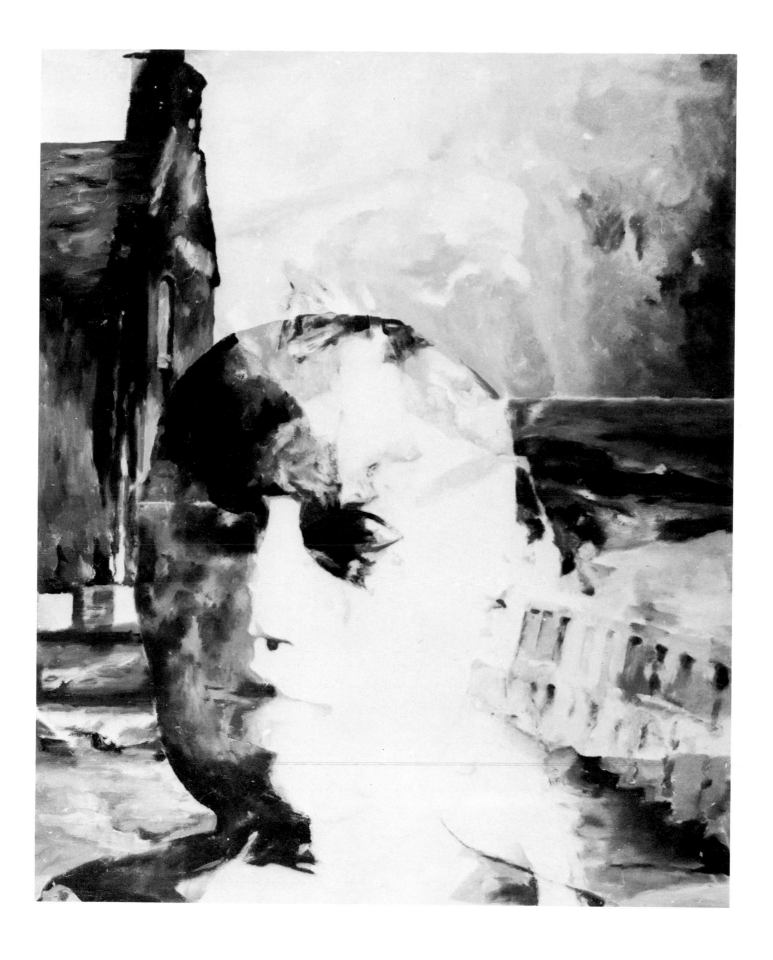

1972 The Sea at Lehinch *113*

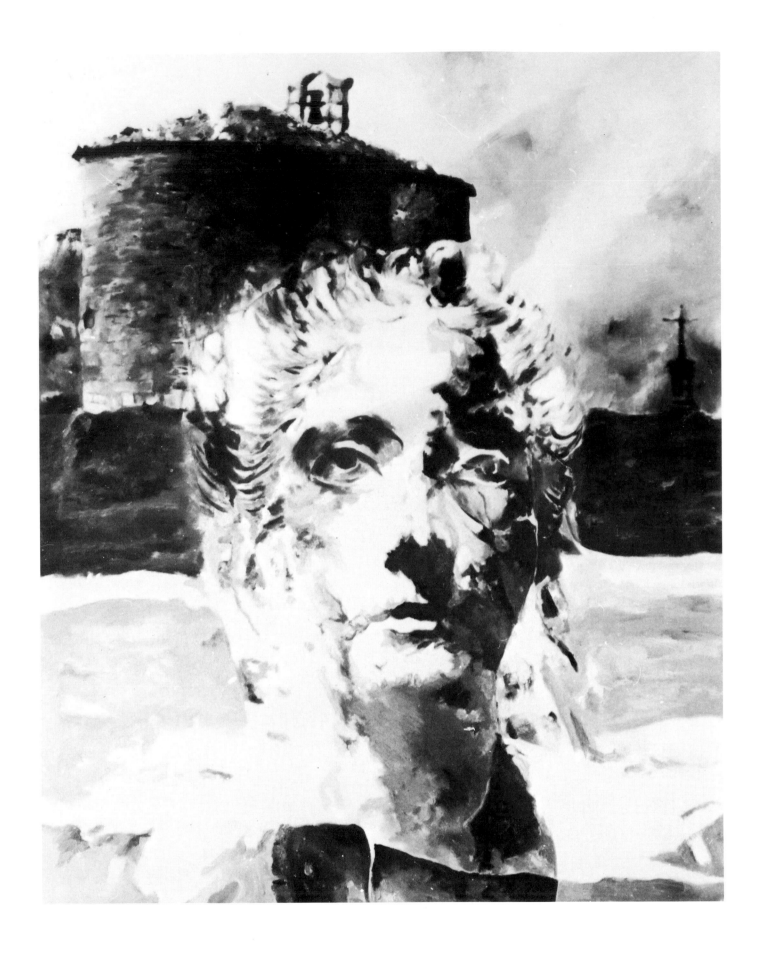

114 1972 Ophelia

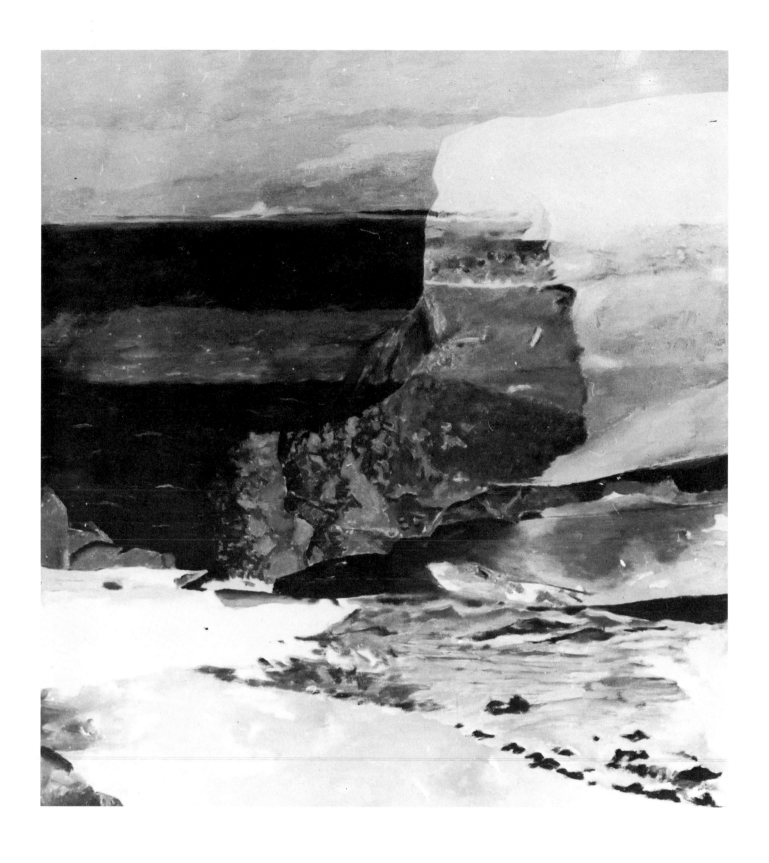

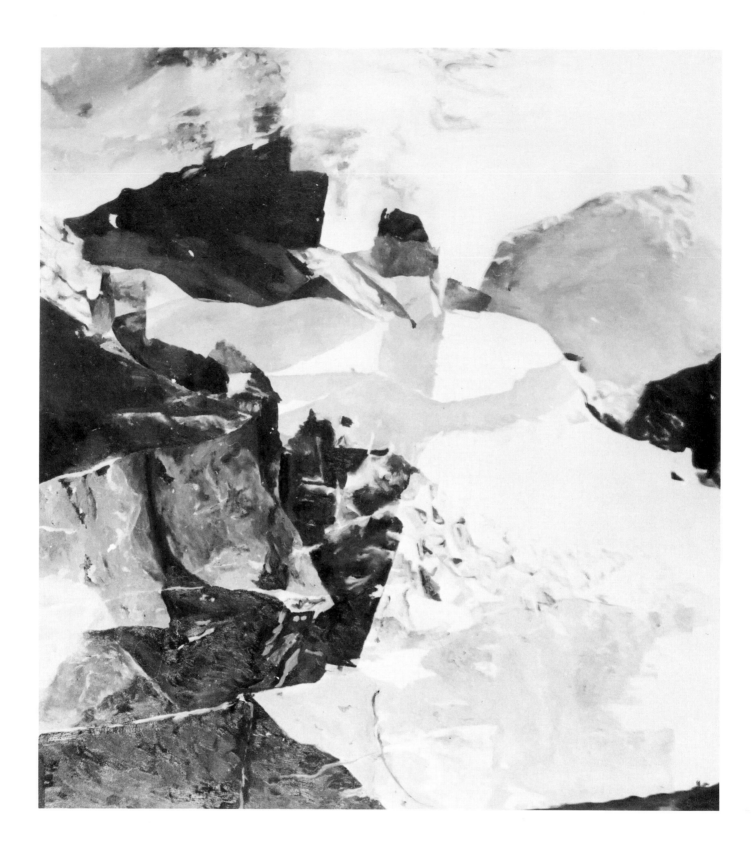

116 1972 Landscape by the Sea

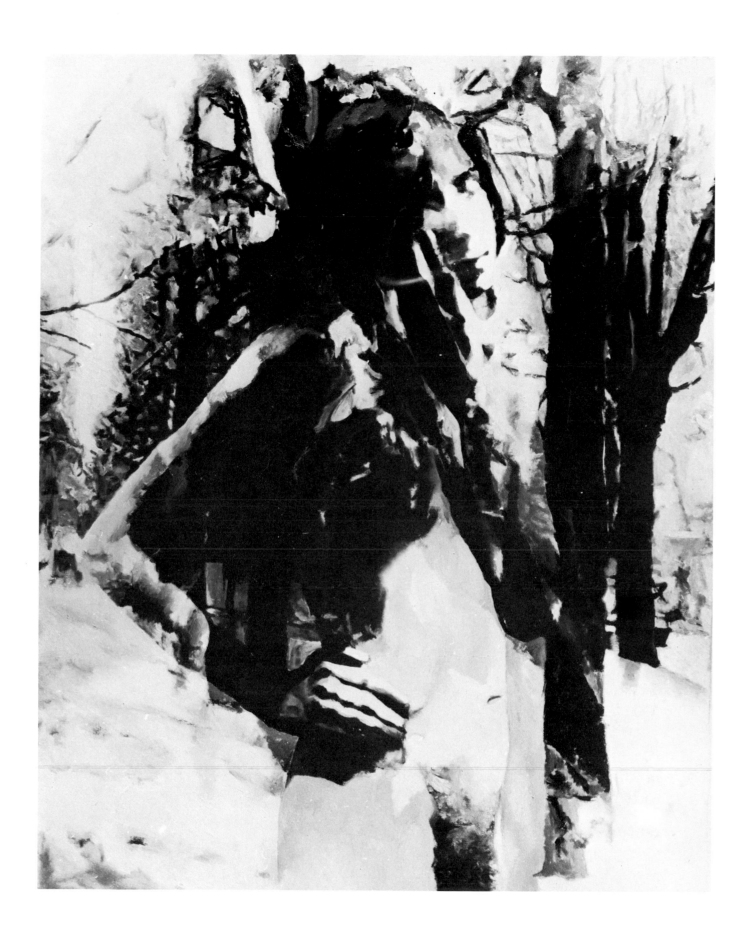

1974 Edge of the Park *117*

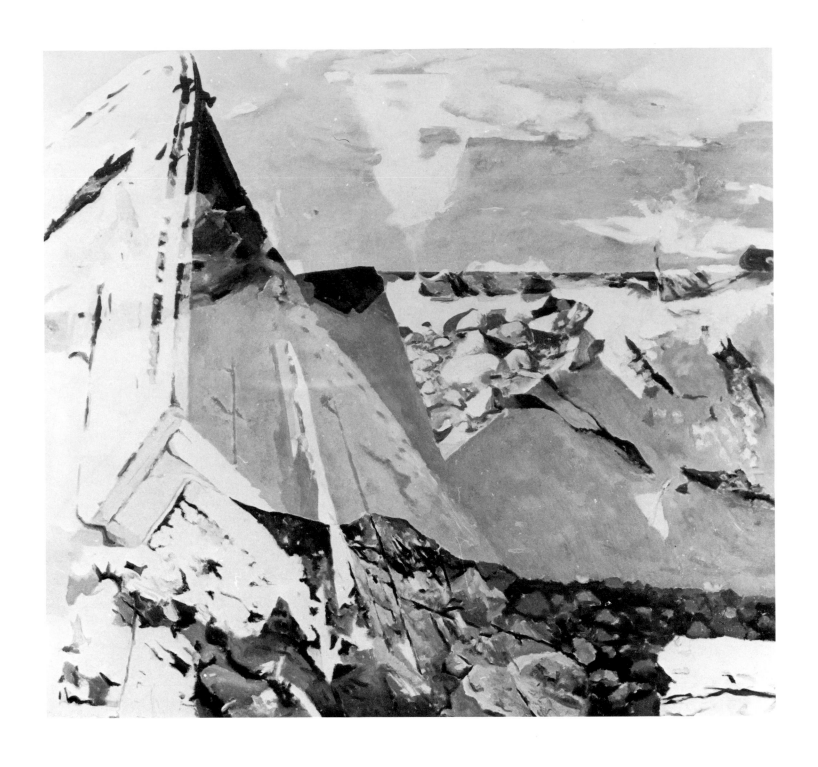

118 1974 The Wreck Near Driftwood Cove

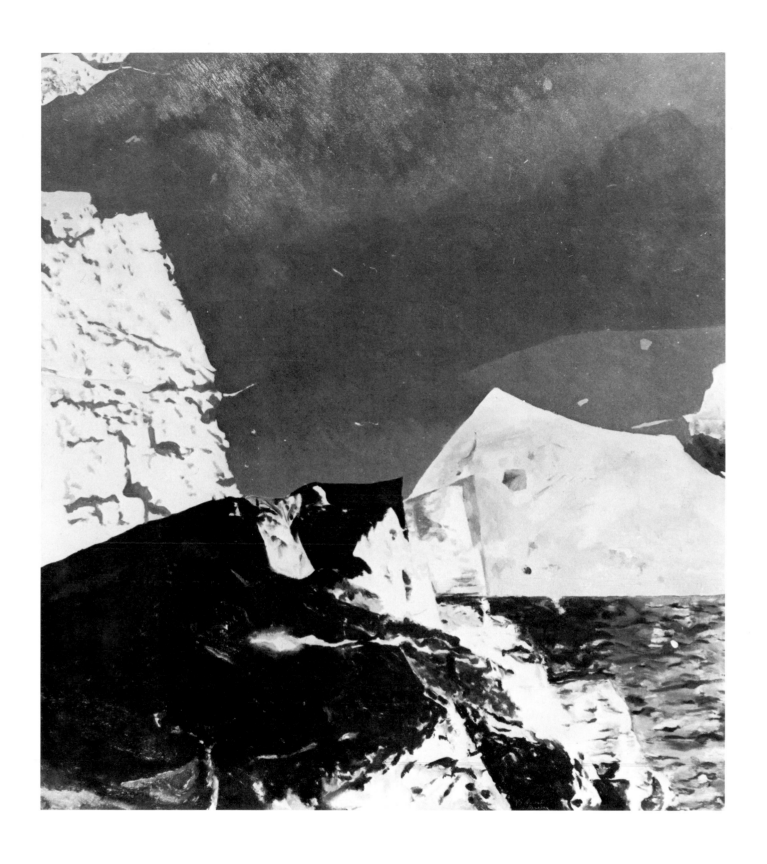

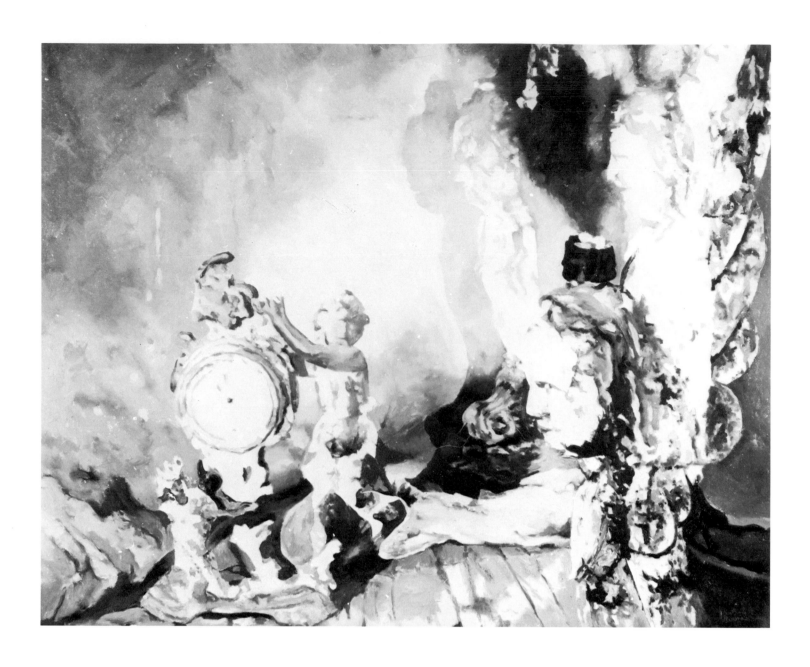

120 1974 Clock and Candlesticks

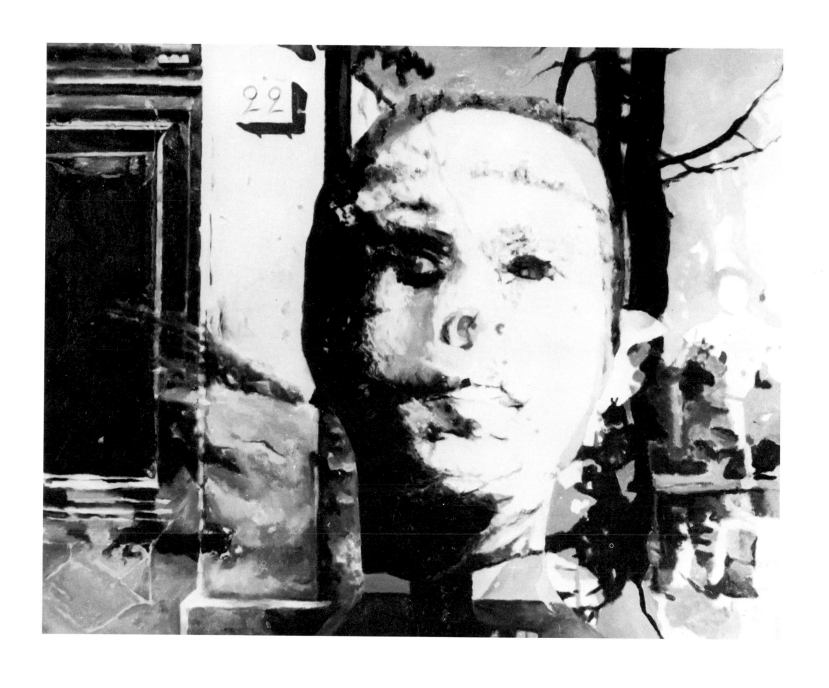

1974 House on the Park *121*

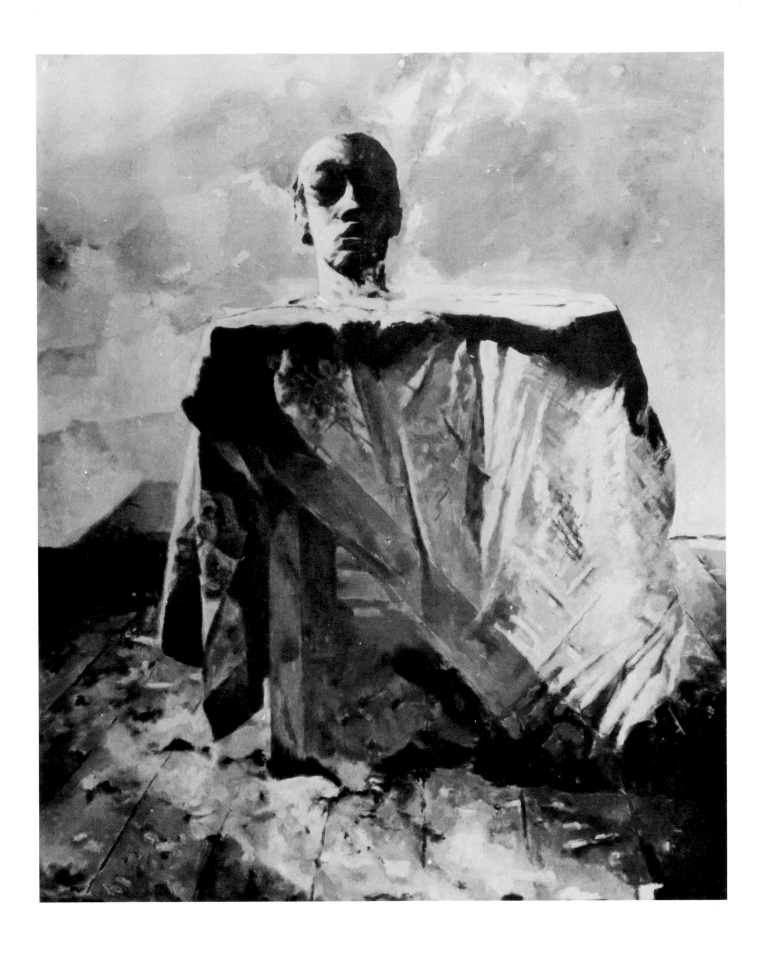

122 1974 Sculptor's Head

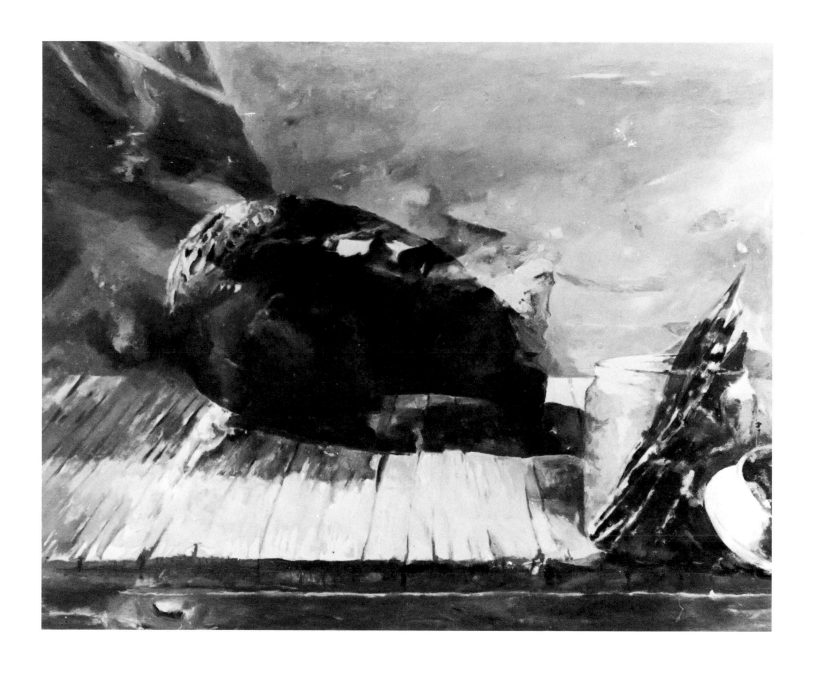

1974 Still Life with Granite Head *123*

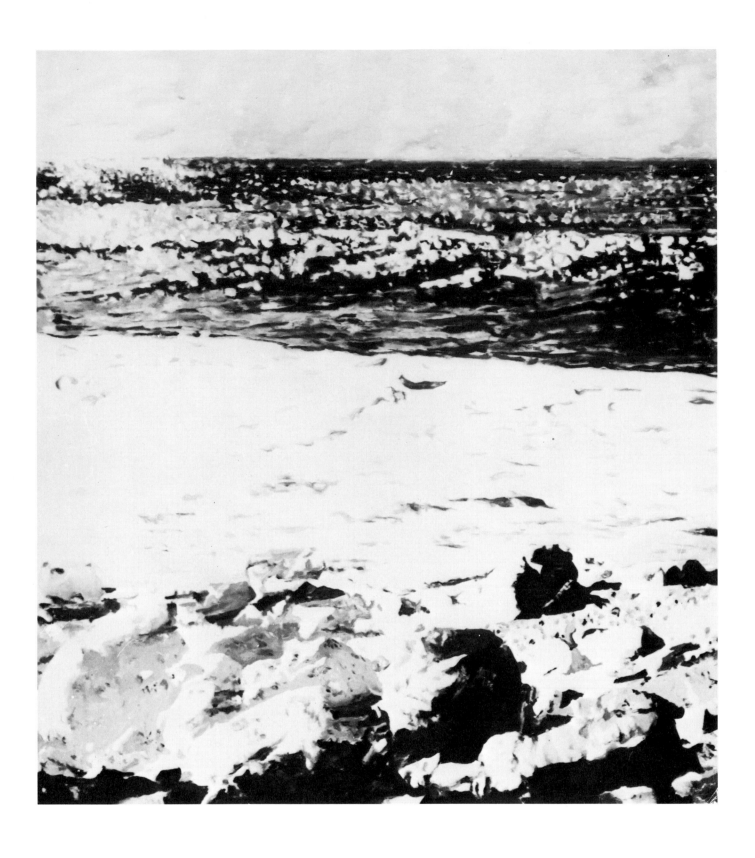

124 The Sparkling Sea

1. Greene, Balcomb, "Expression as Production," *American Abstract Artists*, (1938), XI.
2. *Art News*, (October 1959), p.13.
3. Greene Balcomb, "Congressmen-Flowers-Clench", *Partisan Review* IV, (February 1938), p.39.
4. Larsen, Susan C., "The American Abstract Artists: A Documentary History 1936-1941", *Archives of American Art Journal* vol.14, no.1, (1974), p.6.
5. Taylor, Francis Henry, "United States," *College Art Association International*, (1933), p.11.
6. Cortissoz, Royal, "From the Primitives to the Modernists", *New York Herald Tribune*, (December 8, 1929).
7. Benton, Thomas Hart, *An American in Art*, (University of Kansas Press, 1951), p.151.
8. Larsen, Susan, C., *op. cit.*, p.2.
9. Greene, Balcomb, *American Abstract Artists*, *op. cit.*, XI.
10. *Ibid.*, XI.
11. Larsen, Susan C., *op. cit.*, p.3.
12. Morris, George, *American Abstract Artists*, (1939).
13. *Ibid.*
14. *Ibid.*
15. Larsen, Susan C., *op. cit.*, p.6.

16. Greene, Balcomb, "The Fourth Illusion, or Hunger for Genius," *Art News* (September 1957), p.50.
17. *Ibid.* p.46.
18. *Ibid.*, p.50.
19. *Ibid.*, p.48.
20. Greene, Balcomb, "Basic Concepts for Teaching Art", *College Art Journal*, (Autumn 1948), p.21.
21. Greene, Balcomb, "The Painter Examines the Social Contract", *Art News*, (April 1956), p.56.
22. *Art News*, (April 1952), p.46.
23. *Art News*, (November 1956), p.36.
24. Baur, John I.H., *Balcomb Greene*, (New York 1961), p.14.
25. *Art News*, (March 1962), p.13.
26. Preston, Malcolm, "Painter Balcomb Greene at his Height", *The Christian Science Monitor*, (April 21, 1973), p.14.
27. Genauer, Emily, "Friday Tour of Art", *World Journal Tribune*, (November 18, 1966), p.44.
28. Greene, Balcomb, "The Art of Regimentation", *South Atlantic Quarterly*, (1962), p.309.
29. Baur, John I.H., *op. cit.*, p.7.
30. *Time*, "Magic Ambiguity", (June 16, 1961), p.64.

Selected Bibliography

American Abstract Artists, 1939, illus.
Art Digest, "Fifty-Seventh Street in Review," April 1947, p.20. illus.
Art Digest, "Symposium: The Human Figure", November 15, 1953, pp.12, 13, 33.
Art Digest, April 15, 1952, p.16, illus.
Art Digest, "Artist Bedazzled," January 1954, p.15, illus.
Art Digest, January 1955, p.24, 25. illus.
Art Digest, November 1958, p.56, illus.
Art News, April 1947, p.44.
Art News, May 1950, p.49, illus.
Art News, "The Year's Best: 1950", January 1951, p.43, 59, illus.
Art News, April 1952, p.46, illus.
Art News, January 1954, p.67, illus.
Art News, January 1955, p.48
Art News, November 1956, p.36, 67, illus.
Art News, October 1958, p.12.
Art News, October 1959, p.13, illus.

Art News, "The Year's Best: 1958", January 1959, p.45, illus.
Art News, March 1962, p.13.
Art News, December 1962, p.15.
Art News, November 1963, p.49.
Art News, April 1965, p.11.
Art News, December 1966, p.11.
Art News, November 1968, p.14.
Artes de Mexico, "Segunda Bienal Interamericana, de Mexico," 1961, p.16.
Arts, November 1956, p.62, illus.
Arts, December 1966, p.61.
Arts, November 1968, p.69.
Baur, John I.H. *Nature in Abstraction*, New York, Macmillan, 1958, p.37, 68, 69, illus.
Baur, John I.H. *Revolution and Tradition in Modern American Art*, Cambridge, Harvard University Press, 1951.
Cahill, Holger. "In Our Time," *Magazine of Art*, November 1946, p.323, illus.

Chevalier, D. "Les Expositions a Paris," *Aujourd'hui*, February 1960, p.40.

Coke, Van Deren. *The Painter and the Photographer*, Albuquerque. University of New Mexico Press, 1972.

deKooning, Elaine. "Greene Paints a Picture," *Art News*, May 1954, p.34, 37, 48, 50-51, illus.

Design Quarterly, "10 Artists in the Margin," 1954, p.9-11, illus.

Eliot, Alexander. *Three Hundred Years of American Painting*, New York, Time Inc., 1957.

Ellis, Joseph Bailey, "Art in Progress," *Carnegie Magazine*, February 1943, p.261, 263, illus.

Ewing, C. Kermit, "Out of the Smog," *Carnegie Magazine*, March 1947, p.227, 229, illus.

Frost, Rosamund, *Contemporary Art*, New York, Crown, 1942.

Gage, Otis. *Arts and Architecture*, March 1955, p.39-40, illus.

Greene, Balcomb. "American Perspective," *Plastique*, Spring 1938, p.12-14, illus.

Greene, Balcomb. "The Artist's Point of View," *Magazine of Art*, November 1949, p.267-269, illus.

Greene, Balcomb. "The Artist's Reluctance to Communicate," *Art News*, January, 1957, p.44-45.

Greene, Balcomb. "Differences over Leger," *Art Front*, January 1936, p.8-9.

Greene, Balcomb. "Expression as Production," *American Abstract Artists*, 1938, XI, illus.

Greene, Balcomb. "I Paint as I paint," *American Artist*, June 1944, p.32-35.

Greene, Balcomb. "The Fourth Illusion, or Hunger for Genius," *Art News*, September 1957, p.46-50.

Greene, Balcomb, "Basic Concepts for Teaching Art," *College Art Journal*, Autumn 1958, p.21-34.

Greene, Balcomb. "The Doctrine of Pure Aesthetic," *College Art Journal*, Winter 1959-60, p.122-133.

Greene, Balcomb. "The Problem of Expression in Art," *Carnegie Magazine*, February 1949, p.211-213.

Greene, Balcomb. "The Painter Examines the Social Contract," *Art News*, April 1956, p.30-31, 92-93, illus.

Greene, Balcomb. "Art as the Opium of the Elite," *Art News*, February 1961, p.33.

Greene, Balcomb. "A Thing of Beauty," *College Art Journal*, summer 1966, p.364-369.

Grossberg, J. "Exhibition at Saidenberg Gallery," *Arts*, March 1965, p.56.

Harper's Bazaar, "Artists on the Island," July 1951, p.52.

Hess, Thomas. *Abstract Painting*, New York, Viking Press, 1951.

Hood, Sam. "Balcomb Greene. Detour to Abstraction," *Pittsburgh Press*, May 1955, p.6-7, illus.

Janis, Sidney. *Abstract and Surrealist Art in America*, New York, Reynal and Hitchcock, 1944.

Kirstein, Lincoln, and Morris, George, "Life or Death for Abstract Art?," *Magazine of Art*, March 1943, p.110, 118-9, illus.

Krasne, Belle, "Balcomb Greene's Retreat to Likeness," *Art Digest*, April 1950, p.16, illus.

MacGilvary, Norwood, "Associated Artists Prize Winners," *Carnegie Magazine*, March 1946, p.260, illus.

Mastani, M.L.D., "Retrospective at the Whitney Museum and a Show at the Bertha Schaefer Gallery," *Apollo*, July 1961, p.21, illus.

Michelson, Annette, "Paintings at the American Cultural Center, Paris," *Arts*, April 1960, p.21.

New York Exhibitions. *MRK's Art Outlook*, March 1947, p.2, 4, illus.

New York (City), Bertha Schaefer Gallery. *Balcomb Greene—20 Years of Painting*, foreword by Harris K. Prior, 1959, illus.

New York (City). Whitney Museum of American Art. *Abstract Painting in America*, 1935.

Petersen, V. "Greene Thoughts in a Greene Shade," *Art News*, summer 1961, p.34-5, illus.

Preston, Malcolm, "Painter Balcomb Greene at his Height," *The Christian Science Monitor*, April 21, 1973, p.14, illus.

Raynor, V. "Retrospective at the Whitney," *Arts*, September 1961, p.32-5, illus.

Ritchie, Andrew Carnduff. *Abstract Painting and Sculpture in America*, New York, Museum of Modern Art, 1951.

Selz, Peter. *New Images of Man*, New York, Museum of Modern Art, 1959.

Selz, Peter, "Nouvelles Images de l'homme," *Oeil*, February 1960, p.51.

Seuphor, Michel. *Dictionary of Abstract Painting*, New York, Tudor, 1957.

Tillim, S., "Exhibition at the Saidenberg Gallery," *Arts*, December 1962, p.47.

Tillim, Sidney, *Arts*, October 1959, p.51, illus.

Time, "What the Museums are Buying," June 25, 1956, p.74-5.

Time, "Magic Ambiguity," June 16, 1961, p.64-7, illus.

Urbana, University of Illinois. *Contemporary American Painting*, 1952.

Urbana, University of Illinois. *Contemporary Painting and Sculpture*, 1959.

1904 Born May 22, Millville, New York.
1907 Florence Stover Greene died.
1926 B.A. degree from Syracuse University.
1926 Married Gertrude Glass.
1927 Studied at Columbia University.
1928 Taught English Literature at Dartmouth College.
1929 Bertram Greene died.
1931 Left Dartmouth College: studied at the Académie de la Grande Chaumière, Paris.
1935 First president of the Artists' Union.
1935 Editor of *Art Front*.
1937 First chairman of the American Abstract Artists.
1939 Chairman again of the American Abstract Artists.
1939 Member of the WPA.
1941 Chairman for the third time of the American Abstract Artists: resigned in 1943.
1942 Associate Professor of History of Art and Aesthetics at Carnegie Tech, Pittsburgh.
1943 M.A. degree in the History of Art from New York University.
1950 One man exhibition at the Bertha Schaefer Gallery—nominated by *Art News* as one of the year's ten best.

1955 Exhibition again nominated by *Art News* one of the year's ten best.
1956 Exhibition for the third time nominated by *Art News* one of the year's ten best.
1956 Gertrude Greene died.
1959 Resigned from Carnegie Tech, Pittsburgh.
1959-60 Lived and worked in Paris for six months.
1960 One-man exhibition Whitney Museum, New York. One-man exhibition Paris, U.S. Department of State, interviewed by Terry Trimpen for Radio Diffusion Télévision Française.
1961 Married Terry Trimpen.
1963 Lived and worked in Paris for four months. Artist in Residence—Cannes, France for two months courtesy Henry Clewes Foundation.
1967 Travelled through Italy, Spain, France, Portugal and Morocco.
1975 Travelled to Ireland, England, Paris.
1976 Altman First Prize in Figure Painting.
1976 Joined National Institute of Arts and Letters.
1977 Lives and works at Montauk Point and New York.

Selected One-Man Exhibitions

Gallery in Paris, France, 1932
J.B. Neumann's New Art Circle, New York City, 1947
Annually at Bertha Schaefer Gallery, New York, 1950 through 1961
Arts and Crafts Center, Pittsburgh, Pennsylvania, 1953, 1966
American University, Washington, D.C., 1957
Brookhaven National Laboratory, Long Island, New York, 1959
Centre Culturel Americain, American Embassy, Paris, France, 1960
Retrospective at the Whitney Museum of American Art, New York City, 1961
Everhart Museum, Scranton, Pennsylvania, 1961
Carnegie Institute, Pittsburgh, Pennsylvania, 1961
Mount Holyoke College, South Hadley, Massachusetts, 1961
Bowdoin College, Brunswick, Maine, 1961
University of Massachusetts, Amherst, Massachusetts, 1961
Munson-Williams-Proctor Institute, Utica, New York, 1961

Saidenberg Gallery, New York City, 1962, 1963, 1964, 1965, 1967, 1968
Feingarten Galleries, Los Angeles, California, 1963, 1964
Feingarten Galleries, Chicago, Illinois, 1963
La Jolla Art Center, La Jolla, California, 1964
University Gallery, University of Florida, Gainesville, Florida, 1965
Tampa Art Institute, Tampa, Florida, 1965
James David Gallery, Coral Gables, Florida, 1965, 1966
Main Street Galleries, Chicago, Illinois, 1966
Phoenix Art Museum, Phoenix, Arizona, 1966
Adele Bednarz Galleries, Los Angeles, California, 1966 through 1969, 1971, 1972, 1974
Occidental College, Los Angeles, California, 1967
Berenson Galleries, Bay Harbor Islands, Florida, 1967, 1968, 1969
Mackler Gallery, Philadelphia, Pennsylvania, 1968
Forum Gallery, New York City, 1970, 1972
Harmon Gallery, Naples, Florida, 1974, 1975, 1977
ACA Galleries, New York City, 1977

Index

Albers, Josef, 14
Baur, John I. H., 19
Bengelsdorf, Rosaline, 14
Benton, Thomas Hart, 13
Breton, André, 12, 18
Cézanne, Paul, 20
Conrad, Joseph, 11
Cortissoz, Royal, 13
Ernst, Max, 18
Feininger, Lyonel, 14
Francis, Emily, 12
Freud, Sigmund, 11, 18
Gallatin, A. E., 13
Genauer, Emily, 19
Grabowski, Stanislaw, 12, 20
Greene, Bertram, 10
Greene, Florence Stover, 10
Greene, Gertrude, (Glass) 11; 14, 20
Greene, Nathanael, 10
Guggenheim, Peggy, 18
Hale, Niké, 9
Hale, Robert Beverly, 9
Hirshhorn, Joseph, 19
Hofmann, Hans, 14
Holty, Carl, 14
Holtzman, Harry, 14
Homer, Winslow, 16
Kaplan, J. M., 19

Kaufmann, Irene, 19
LaFarge, John, 16
Lassaw, Ibram, 14
Léger, Fernand, 16
Manet, Edouard, 17
Matisse, Henri, 12, 13
Matisse, Pierre, 18
Modigliani, Amedeo, 13
Moholy-Nagy, Lazlo, 14
Munch, Edvard, 17
Mylonas, George, 9
Neuberger, Roy, 19
Neumann, J. B., 19
Picasso, Pablo, 12, 13, 16
Preston, Malcolm, 19
Reinhardt, Ad, 16
Sargent, John Singer, 16
Schaefer, Bertha, 18, 19
Shaw, Charles G., 14
Stover, Mary, 10
Taylor, Francis Henry, 13
Tobey, Mark, 12
Tomlin, Bradley, 12
Trimpen, Terry, 20
Tzara, Tristan, 12
Wesley, John, 10
Wheelock, Warren, 14

PRODUCTION CREDITS

Type: Bodoni Book

Composition: Precision Typographers

Printing: Vicks Lithograph and Printing Corporation

Paper: Wedgwood, supplied by Edition Book Paper Company

Binding: Publishers Book Bindery